## NEW WORK ON PAPER 1

This is the first in a series of exhibitions organized by The Museum of Modern Art, New York, each of which is intended to show a relatively small number of artists through a broad and representative selection of their recent work on paper. Emphasis is placed on new work, with occasional glances backward to earlier production where the character of the art especially requires it, and on artists or kinds of art not seen in depth at the Museum before. Beyond this, no restrictions are imposed on the series, which may include exhibitions devoted to heterogeneous and to highly compatible groups of artists, and selections of work ranging from traditional drawing to works on paper in media of all kinds. Without exception, however, the artists included in each exhibition are presented not as a definitive selection of outstanding contemporary talents but as a choice, limited by necessities of space, of only a few of those whose achievement might warrant their inclusion — and a choice, moreover, that is entirely the responsibility of the director of the exhibition, who wished to share some of the interest and excitement experienced in looking at new work on paper.

NEW WORK ON PAPER 1

JOHN ELDERFIELD

THE MUSEUM OF MODERN ART, NEW YORK

Designed by Keith Davis
Type set by Concept Typographic Services,
New York, New York
Printed by Rapoport Printing Corp., New York,
New York
Bound by Sendor Bindery, Inc., New York,
New York

The Museum of Modern Art
11 West 53 Street
New York, New York 10019

Printed in the United States of America

"New Work on Paper 1" has been organized
with the aid of a grant from the National
Endowment for the Arts in Washington, D.C.,
and is dedicated to the Endowment on the
occasion of its fifteenth anniversary.

## PHOTO CREDITS

Dave Allison, New York, p. 47; Jonathan Bayer, London, p. 40; Rudolph Burckhardt, New York, pp. 35, 36, 37; Jill Crossley, New Zealand, p. 49; M. Lee Fatherree, Berkeley, California, pp. 31, 33; Kate Keller,* pp. 19, 20, 21, 23, 24, 25, 27, 28, 29, 43, 44, 45; Mali Olatunji, New York, p. 32; Rodney Todd-White, London, p. 41; Andrew Watson, London, p. 39.

*currently staff photographer, The Museum of Modern Art, New York.

# CONTENTS

This is an exhibition of works on paper made in the past few years by eight artists, all of whom I believe to be producing fine and important work and for whom the use of paper, either for making what are unquestionably drawings or for making objects of other kinds, is essential to their artistic practice.

Much that I have to say about the exhibition deals with certain broad concerns — principally with image-making and with the reenrichment, and at times reinvention, of traditional modern forms — that seem to link in different ways what these artists are doing. It is important, therefore, to remind ourselves from the start just how various their work is.

Of the eight artists in the exhibition, one, William Tucker, is a sculptor who has been producing full-scale drawings for his three-dimensional work. Another, Tom Holland, is a painter-collagist who works in both reliefs and three dimensions. Two of the artists, Yvonne Jacquette and Ken Kiff, may be described as realists, though of almost opposite persuasions: the former basing her work on the observed world, the latter on the world of his imagination. Two are abstract artists, in their work on paper as in their paintings, though again quite different in approach: Alan Cote makes drawings in abrasive monochrome while Dan Christensen uses soft and lyrical color. Finally, two of the artists occupy, at least in their work on paper, regions half-way between realism and abstraction: Jake Berthot, though an abstract painter, makes drawings that have their source in objects of the world, while Joan Snyder uses imagery of a diaristic and symbolic nature, and at times employs a range of materials that far exceeds that of traditional drawing.

The work of one or two of these artists may be unfamiliar to many observers. The exhibition, however, no more aims at the "discovery" of new art than it attempts to review firmly established reputations. Most of the artists in the exhibition are in fact well known to those who follow contemporary art; most first came to public attention some ten or more years ago. But all are still what we like to call "younger" artists: that is to say, in their late thirties and early to mid-forties, which is the age when most serious modern artists begin truly to come into their own. My decision finally to concentrate on selected members of this generation was one of only two consciously programmatic acts in my organization of this exhibition. The other was to bring together within a single exhibition space work that seemed reasonably compatible, while keeping the exhibition open and catholic at the same time. Beyond those decisions, the exhibition concentrates on showing what I understand to be recent work of quality, without pretending, however, either to be fully representative, even of that generation, or to be a critical pantheon of any kind. (It does, in fact, include some of those who I think are among the best artists of their generation, but it does not include them all.)

If this exhibition does have a certain coherence and identity despite the broad range of work that it contains, it is not because it defines anything (a group, a school, even a trend), but because it reflects something, namely a set of attitudes that in different ways pervades the work of many members of this generation of artists that first emerged in the later 1960s. I discuss these attitudes (at least, as I see them) as I review the work of these eight artists, not only because I think it aids apprecia-

tion of their work, but also because theirs was the first generation to have had to come to terms with important recent changes in the whole cultural climate within which modern art is made — and that now affect virtually all ambitious modern artists except firmly established ones, and even some of those. And while what I have to say about these things should be understood as applying specifically to the eight artists in the exhibition, some of it may have broader significance, both for other artists of their generation and for those of other generations as well.

**O**ne attitude that pervades the work of nearly all of the artists in this exhibition is the desire to enrich an apparently over-attenuated modern tradition through a return to image-making of different kinds, whether in an abstract or a specifically realist context.

Image-making, that basic and traditional function of pictorial art, has frequently assumed a somewhat problematic role within the advanced art of our time, and largely because of the doctrine of the autonomy of the object that modernism reinforced if not actually created. That optimistic belief in a self-contained work of art with its own order, its own materials, its own independence in a world of objects has tended often to militate against anything that seemed separately to address the viewer from within the work, lest the work itself become merely a vehicle or ground and thus surrender the address that it as a whole would make. This accounts for, among other things, the tendency to want to tie or otherwise align imagery to the geometry

of the support, the tendency to modular and all-over forms, and the sense of emotive coolness in imagery itself that have characterized art of the Cubist-derived tradition and that climaxed in the art of the 1960s. The attempt to enrich structures of this kind with a new sense of iconic vigor, but without surrendering the "modern" wholeness of the object, has since the 1960s particularly affected a significant amount of realist art, which in effect opposes a "modern" structure with formal and iconographical disturbances that threaten to destroy that structure but that end up by reinforcing it in a new way.

The work of Yvonne Jacquette is usefully considered in this very context. Her interest in serial imagery and at times in modular structures (diptychs and triptychs) links her work to familiar modernist preoccupations. So does her use of a relatively large format for what are still perceived as drawings — for the attempt to expand drawing to the status of an independent art, equivalent to painting, was one of the characteristics of avant-garde art in the 1960s. But just as important as scale to Jacquette is her all-over touch (and her attraction to dark subjects, which gives her touch a far greater prominence than did her earlier light subjects), since it is this that gives material density and cohesion to the rich and velvety surfaces in which her now usually negative figuration seems to be embedded. The architectural motifs she often uses also, of course, reinforce the geometric wholeness of her compositions, but the newer drawings of illuminated highways and bridges suggest that touch itself is what is really crucial.

The all-over surface density of Jacquette's work, married as it is

to metropolitan subjects seen from above, must inevitably recall certain Impressionist prototypes. The casualness of the Impressionist viewpoint, however, has been set hard and formalized by the intervening experience of abstraction. (I am reminded in this context more of Malevich's illustrations of aerial views "which stimulate the Suprematist" in his *Die Gegendstandslose Welt*.) Part of the beauty of her work lies in its fixing such inherently spectacular subjects to a rigidly abstract surface that holds the eye on its warm and grainy monochrome. But also intervening here is the experience of photography, and while Jacquette does actually draw from airplane windows to make her composite views of motifs thus fragmentarily seen, still something of the cropping of the motifs, and of the way they seem to describe by synecdoche the larger urban whole, recalls the action of the camera. Or perhaps it is just the objectivity of these images, and the way they seem to be embedded in the skin of the surface as photographic representations are trapped in their surface emulsion, that suggests this comparison. Certainly an assumption of distance from her subject-matter that is psychological as well as literal characterizes Jacquette's art, and this helps to bond her dramatic subjects to her almost minimalist sense of form.

A similar bonding of minimalist-derived structures and what are, potentially at least, iconographical disturbances may also be observed in Joan Snyder's work. Although her eclectic, inclusive use of materials and highly emotive, diaristic imagery firmly separates her art from the cool, deductive approaches of the 1960s, her use of an often explicitly geometric framework on which to hang such materials and such imagery reminds us of the context from which her art first emerged.

Her earliest totally individual works used a grid format as a kind of writing pad, she once said, on which to place drifts of individually-charged brushstrokes, each of which had a sense of weight and presence — a sense of identity, in fact — such as traditionally belonged to figurative imagery. The accumulation of such abstract characters continues in the recent work, as also at times does the all-over grid (and if not that, some other kind of surface geometry). However, the only implicitly narrative association of marks in the earlier pictures has now been replaced, in sections of the recent ones, by clusters of marks that unquestionably form trees, houses, words, and so on. The coexistence thus established between the "abstract" and the "real" adds both a new semantic as well as iconographic richness to Snyder's art and allows her to conjure up a highly personalized and intimate poetry — at times nostalgic, at others almost brutal — that "belongs" to the very materials that create it.

Matching the introspective imagery of Snyder's work is a sense of technical introversion. A geometrically structured ground will be disrupted by a wide range of different graphic and liquid media, and by added materials too, and will be "damaged" at times by tearing, scoring, and painterly scratching. It is as if the debris and scars of painful as well as pleasurable experiences have defaced the clean record of an otherwise ordered existence. What thus subverts form is itself, of course, formal; still, it is in part because of the play and tension achieved between what we perceive as the ordered and the allusive components of Snyder's art that her hybrids achieve their force. Even more than in Jacquette's work, that originally Cubist sense of dislocation between the abstract structure of the work of art and the

"reality" of the imagery that fills it is central to what Snyder does.

To note that this tension or opposition between structure and imagery is not present in Ken Kiff's work is not to say that it is any the better or the worse for it; rather, that of all the artists in this exhibition, he is perhaps the one who seeks most determinedly to circumvent the Cubist tradition. In doing so, however, he looks back to another side of modernism. The emotive and autobiographical focus of his art is not essentially that different from Snyder's but, whereas her art will at times evoke Klee, his — though based in the very deepest admiration of this artist — will more likely recall Nolde, Chagall, or Redon, as well as an earlier tradition of fantastic and Romantic art for which the act of image invention was always of essential importance.

Kiff's work draws very explicitly on a rich heritage of mythical and elemental imagery. Both in his watercolors and in that group of pictures on paper begun in 1971 and now numbering nearly 200 that he calls "A Sequence" and considers a single work, we find a *dramatis personae* that would not be out of place in the fairy tales of any Western culture. (He in fact illustrated a volume of *Folk Tales of the British Isles* in 1977.) Swollen, fetal heads and deformed anatomies — at times grotesque and threatening, at others beneficent and gleeful — and a stock of archetypal properties including lakes, volcanoes, castles, and boats, inhabit his imaginary landscapes. Kiff's imagery, however, is not entirely atavistic, being mediated if not tempered by the experience of Jungian analysis (as is made clear by the largest of his works in the exhibition); and if a single iconographical theme does run through his work it is the charting of an obviously modern voyage of discovery into the primal interior of the imagination.

It would be wrong, though, to think of his work as simply illustrational. What gives it its uncanny power is the remarkable coincidence that Kiff achieves between iconographic and stylistic invention. Even without knowing from the artist that decisions about style and subject are made together — that the form of the subject-matter owes as much to pictorial as to thematic imagination — we recognize this in his work: in the rhyming and correspondence of the images through which these bizarre narratives are told; in the sense of interaction and reciprocation between figure and ground that itself tells of the issues of separateness and belonging, of alienation and accord, that the subjects themselves provoke; and in the invention of shape itself by movements of dense paint across the circumscribed surfaces that reinforces both the fluidity and the earthiness of this private world.

It is as well to remind ourselves at this point that the "return" to image-making of different kinds that characterizes much recent art, and the appearance also of kinds of art that seek to bridge realism and abstraction, are by no means new. Each clearly presents itself as a reaction against the more programmatic and reductive forms of recent modernism; that reaction, however, draws upon and does not repudiate modernism itself.

Certainly, over the past decade or so we have seen a new sense of fragmentation in modern art, and the initiation of a new period of eclecticism, flux, and sometimes bewildering change.

The "heroic" period of postwar modernism would seem to have given way to an extremely open situation in which coexist a wide variety of different approaches to art-making (if not such a variety of styles as is sometimes claimed) and an even wider variety of qualitative achievement. However, to describe all this under the banner of "post-modernism," as is often done, is really to beg the question: it neglects the incidence of comparable situations in earlier periods of modern art (the 1930s – early 1940s is the most obvious example); it minimizes the often very considerable dependence of the new art on earlier modernism; and most importantly, it tends to avoid serious reflection on what is especially valuable among all that is now being made, replacing evaluation of this kind with a passive and permissive acceptance of the "pluralism" of recent art. Recent art is indeed pluralist in the sense that no single new approach has achieved dominance, but that is as much a function of the audience for new art as of the art itself. And besides, modernism was not always as circumscribed a thing as it became in the theoretically self-conscious avant-garde of the recent past. It is the constraints of recent modernism and the restrictions of avant-garde theory that the best of the new art rejects, not modernism itself.

There is, perhaps, some pattern to be found in what has been happening over the past decade or so. There is too little evidence to be categorical about this, but it does appear that realism and image-making start to come to prominence when a major, innovative modern style passes from its moment of innovation to the achievement of an established status, and is challenged on the grounds of its aestheticism and therefore, sup-

posedly, its escapism. Realism and image-making come to prominence, moreover, both in opposition to more rigorously abstract developments from the original innovative style, and as a complement to these developments, sharing some of their stylistic features. (Hence the emergence of both realist and abstract image-making alongside geometric abstraction after World War I, when the essential revolutions of Fauvism and Cubism had been established. Also, the appearance of different forms of realism, including Pop art, in the later 1950s and 1960s alongside more rigorous extrapolations of Abstract Expressionist field painting and then Minimalist art.) This then seems to be followed by a period of eclectic stylistic meldings and hybrid forms that draw, in various ways, on the broadened modernist options thus created. (Hence the technical and stylistic recomplication of new abstract art, and the creation— alongside established realist and abstract art — of art that blended realism and abstraction both in the 1930s - early 1940s and in the 1970s.) This is, of course, to drastically simplify two different situations, and I by no means intend any exact parallel, nor admit any element of prediction in all this. It may well be, as some do insist, that modernism has all but run its course, and that we cannot expect the present period of flux to produce anything as strong and important as last eventually emerged from such a situation. But new art, and not new theorizing, is what will answer that.

For the moment, we must simply rely on art that is now being made, and notice a broad attempt to graft a more vigorous stock onto a mainstream that has grown, in some hands, thin and sickly through overcultivation. Most of the artists in this

exhibition first came to public attention before it was finally clear that the optimistic progress of postwar modernism had run into difficulties. Most inherited the optimism of that earlier period; all have had to survive the struggle to make serious works of art in the face of an increasingly disorienting artistic climate. That burden is not, of course, theirs alone, nor only that of their generation. But their generation was the first to feel and respond to the changes that younger artists are now feeling. For them, at least, the challenge is to escape the constraints that recent modernism has created, and reinvent their modernism for themselves.

We see this very explicitly in Jake Berthot's recent work, and particularly in his drawings. From the start, his paintings had attempted to reinvest reductive, minimalist structures with a sense of traditional authority by using fixed, logical shapes whose logic was dissolved in the immaterialized grisaille surfaces that surrounded them. The implicit romanticism of the paintings appears unchecked in many of Berthot's works on paper, and never more so than in the series of drawings of skulls he began in 1976.

It is probably relevant to these works that Berthot's first introduction to modern art was through a book on Picasso's paintings of the period of World War II — those somber, moody still lifes of skulls, candlesticks, and the equipment of meager meals. But there is nothing historicist about Berthot's "realism," as there is in much contemporary art (and architecture) that also attempts to retrieve what the rush of modernist extremism has allowed to be forgotten. We do find, as inevitably we must, reminders of

earlier artists that Berthot admires, but there is no quoting in his art. Everything is given with obsessive directness, although it is given in a variety of different ways.

In the first group of skull drawings (1976-77), it is *écriture* that dominates: line that is descriptive but has a sense of abstract independence characteristic of the written sign. Marks of this kind, which hover on the boundaries of showing and telling, slide and skid across wet-painted surfaces, and are joined there by "real" signs: by scribbled-on words and phrases, although ones whose meaning is veiled and obscured. In the second group (1979), a similar blend of imitating and signifying also obtains, but now the images seem threaded together from separate cursive marks and scratches, and the surfaces that contain them are richer and moodier than before. A broad range of neutral, fugitive tones, and a sense of muffled, creamy light (and in the companion negative drawings, of lamp-black darkness) causes the flattened silhouettes of the skulls to seem to float in spectral fashion across the front surface of a poetic, chiaroscuro space. The most recent drawings are generally much smaller, more obsessively descriptive, and contemplative. Some juxtapose now overtly mimetic mark-making (that refers right back to sepia anatomical drawings of the Renaissance) with dense passages of tiny writing; others leave the *memento mori* image virtually alone in its possession of the framed opaque surface and trapped there by the pressure of a space that seems more tangible than what it contains.

Modernism as a whole has been haunted by the question of direct, straightforward contact with the world that its early turn

from illustrated subject-matter has rendered problematic. And it has been even more acutely haunted by its increasing repudiation (from Impressionism to Abstract Expressionism and beyond) of the traditional image-making qualities and "serious" chiaroscuro spaces of earlier art. How to retrieve some of these qualities without denying the achievement of modernism — how to unite modern form and a traditional sense of meaning without, however, using either at arms' length, from an ironical distance — has been crucial to many modern artists. It is one of the questions that drawings like Berthot's address, as do others in this exhibition.

Although very different indeed from Berthot, and as different from one another, both Dan Christensen and Alan Cote are also concerned with the emotively charged image. What separates both of these from Berthot, however, is not only that each refuses explicit reference to the external world, and that each is a "purer" artist in using a more unified and restricted formal vocabulary: it is that for each of them the way their imagery inflects and structures a flat, rectangular surface is of equal, indeed if not greater, importance than the "charge" of the imagery itself.

In the later 1960s both Christensen and Cote began making versions of "color field" painting that emphasized drawing and shaping as well as color. Christensen's spray-gun paintings of that period seem to have been motivated by the desire to create an equivalent kind of all-over cursive drawing as existed in the paintings of Jackson Pollock, but with a wider and more visible range of color than was available to Pollock's style. The paintings that Christensen made in the early and mid-1970s, although stylistically quite various — ranging from broadly geometric combinations of differently colored and textured bands to gesturally-inflected painterly continuums — are linked by his interest in a kind of colored drawing that itself provides the surface structure of the work of art. The recent paintings, and these works on paper that accompany them, return to an even more explicit kind of drawing in color than existed in the spray-gun paintings, but of a kind that builds on both the geometric and the gestural sides of his preceding work.

While all-overness has now been surrendered for figure-ground relationships and for "imagery," the cohesive effect of all-overness nevertheless remains. This occurs because the drawing that makes each picture frankly repeats the geometry of the whole surface — following its corners, its diagonals, or dividing it down the center — as well as displacing that geometry at the same time; and because the color of the drawing either stays quite close in tone to that of the ground or is a thin or whitened or otherwise "light" form of drawing that does not seem to cut into depth; and also because the drawing either lays candidly on top of the flat surface (which seems, therefore, to pass uninterruptedly beneath it) or is embedded against the surface by accents and areas of color that form, as it were, an upper or overlayed surface. And it is from this giving and taking of space across resolutely frontal as well as open surfaces that Christensen's art achieves the formal coherence and stability within which his overtly lyrical sensibility operates.

Certain organic allusions are inevitably suggested by Christen-

sen's work. Its very creation of geometry from gesture invites comparison with spontaneous natural growth, just as the particular structures thus formed invite comparison with specific fragments and forms of the natural world. Associations of this kind are a part of the work, not to be imagined away, and help to give to it its distinctive mood, which is more often than not a pastoral one, telling of the instinctual, of fragile as well as lush beauty, and above all of sensual delectation. We should not suppose, however, that acknowledgement of this in any way compromises the abstractness of the work, for all abstract art, in one way or another, makes concessions to the appearance of things outside of itself, if only because the mind is incapable of inventing other than on the basis of what somewhere exists. The way in which Christensen's work suggests by analogy how nature structures things is by no means unusual in abstract art. Something similar is to be found in Alan Cote's work too.

The dense, sticklike lines from which Cote's recent charcoal drawings are constructed seem far indeed from the elegant, beveled-edged strips that scattered across the fields of color in his paintings of the early 1970s. Nevertheless, Cote (like Christensen) always found a place for explicit drawing in his work no matter how much color was given prominence, and when his art radically began to change some five or six years ago to admit heavier impastoes (as well as earthier colors) and a kind of ragged contouring indebted to Clyfford Still, it was not to dispel drawing but to make it more a part of the whole, worked surface than it was earlier. The geometricization of Cote's art over the past five years gives drawing if anything a greater role than ever before.

Geometricization is as imprecise a term for Cote's roughly carpentered, heavy imagery as it is for Christensen's light and gestural kind. But he too constructs always with reference to the geometry of the sheet, hanging branchlike clusters of marks from its top and sides, building corners and edges within its corners and edges, and pushing about the internal space with the thrusts and movements of irregularly climbing ladders and zigzag lines. Working against this geometric alignment, however, is the abrasive physicality, the sense of tangible weight and presence, that belongs to the constructions he draws, which gives to them an independent reality such as belongs to actual constructions. Like diagramed skeletons of objects, they present a complex but highly generalized architecture of stress, balance, and implied volume that recreates in abstract terms not so much our perception of things in the world but what our bodily experience of them is like.

The insistently syntactical basis of Cote's drawings reinforces this too: the way in which they present themselves as composed in an obviously additive way from separate but mutually reinforcing elements. We see relationships between elements, I think, before we see "images" as such — which separates Cote's work from Christensen's (where syntax, though clearly crucial, is understated) and aligns it more closely in this respect with the tradition of sculptural construction, the tradition to which William Tucker belongs, and whose own sculptures share with Cote's drawings and paintings the creation of open linear scaffolds from expressed sequences of forms and details.

Tucker's recent sculptures have grown, in fact, far more holistic

and objectlike than they were earlier. Although still obviously made up of pieces and parts, and still deriving their unity from our cumulative reading of their components, they now stand up against gravity as motifs. As such, they admit a greater deal of predetermination than did his work that was organized across the plane of the floor. In part because of this, and in part because of his occupying a temporary studio too small to house the size of sculptures he was planning, between 1978 and 1980 Tucker made a remarkable series of full-scale charcoal drawings for his work. Some, like *The Rim, first drawing*, explore and invent what form the sculpture will take. Others, like *Arc with Lintel*, present the envisaged effect of the completed piece.

The first thing to be said about these drawings is that they are stunning *tours de force*. Their huge size, their implied weight and density, the painterly detailing that inflects their geometry, their sense of presence as whole images, and the variety of individual readings their size allows: all these elements contribute to create a kind of "sculptor's drawing" that has more than a little of the feeling of monumental sculpture itself.

In the case of the explorative drawing, it is indeed the feeling rather than the look of large-scale sculpture that we receive. The completed sculpture *The Rim* turned out to comprise two vast steel wheels set side by side with only a narrow strip of space between them, and joined by a regular sequence of crossbars around their common perimeter. The drawing searches for the final diameter of the circle and studies down the center for what the form of its end elevation might be. It also, however, analogizes the mass and the surface inflexions of Tucker's

sculpture in general — and its constructional nature too, in the frankness of the marriage of the separate sheets from which it is made. Whether or not we see the image of *The Rim* in this drawing, we sense in it what the experience of sculpture is like.

Both drawings present motifs that rest solidly on the ground, subject to gravity, but that free themselves from gravity in the rocking movements that the circle and the arc both imply. Tucker would seem to be preoccupied by motifs that allude to architectural constructions and details, and particularly to those — like portals, pediments, and windows — that, although stable, suggest elevation and free-standingness, and that, although solid and whole, surround and open space. In the *Arc with Lintel* drawing, inspired in part by a famous mural sequence at Hampton Court, he turns back to the complexities of Renaissance perspective, using it, however, not as a convention but as an inventive tool with which to modulate the flow and pace of the rhythms he creates across five different windows of space. And if the sculpture itself literally opens to free space as it sets its weight on the ground, while the drawing can do neither of these things, then the wall on which the drawing is placed arrogates to itself the function of the stable ground as it holds suspended in free space this remarkably convincing illusion of weightedness.

Although Tom Holland is represented in this exhibition by fully three-dimensional as well as by relief construction in paper, he is not to be considered a sculptor in the way that Tucker is. His vividly colored and expressionistically handled works do, of course, look back to the same Cubist sources as ultimately

inform Tucker's severe architecture, but each has drawn on these sources in radically different ways. While Tucker associates himself with the other artists in this exhibition who seek to enrich their inherited tradition with a new sense of iconic vigor, Holland seeks enrichment in sensuous complication. In doing so, he suddenly finds himself in the foreground of what is now virtually a whole artistic school, namely that of polychrome assemblage. But he no more belongs now to any school than he did earlier when he was virtually alone in making works of this kind. Indeed, if earlier his reliefs seemed too eccentric to properly fit in with the formalized color art of the late 1960s, now they seem too cooly restrained to be a part of the aggressively environmental relief movement that exists at the moment.

One thing, besides its formalized restraint, that separates Holland's art from most contemporary work in this mode is the priority that it gives to color, and color moreover that is expressed as integral to the surfaces that hold it. And this is why even his three-dimensional pieces cannot satisfactorily be described as belonging to a solely sculptural tradition. Unlike the polychrome sculpture that was popular in the 1960s, Holland's work uses color neither as a servant of space and form (to identify and inflect the movement of open planes), nor to impose a sense of visual wholeness. It uses color instead as a property of pictorial surfaces; and it is the attempt to realize color across surfaces that bend and distort, that break and interlock, and that turn around three-dimensionally, that informs what Holland is doing. He is, in effect, a painter working with sheets of color who makes three-dimensional paintings.

The very large reliefs and free-standing works in epoxy on fiberglass and aluminum that Holland makes are both prepared for and complemented by his smaller paper constructions. Given their medium, these have a sense of fragility and even at times of delicacy that is entirely their own. Working against this, however, is the fact that Holland's painterly touch, when applied to small-scale objects, thickens the surface proportionally more than in the case of larger ones. As a result, they achieve a heavily tactile and physical status, and a richness of detailing, from their globby, viscous surfaces, their hardened drips of epoxy, and their embedded ribbons of collage, as well as from the clipped-edge drawing of the separate sheets from which they are composed.

I said that Holland does not properly fit into any school or movement, although he of course belongs to his time, and his work has affinities with what certain of his contemporaries are doing. The same is true of all the artists in this exhibition. In saying this, I do not principally intend to draw attention to their individuality — though all have achieved individual forms if not always completely original ones; rather, to point out that much of the best art now being made refuses to belong to a school or anything so prescribed.

This might seem to be as much forced onto these artists as willed by them, for there are no dominant new schools to belong to (although there still exist any number of surrogate ones). But if such a situation does now exist, it is the artists in this exhibition, and others like them, who have created it. All accept the

fact that the languages they use, like all living languages, have natural restrictions and limitations, and that new forms are created by challenging these restrictions rather than by attempting to escape them entirely. But all do challenge the restrictions of the schools of the recent past, seeking instead a freedom of action that is more inclusive and eventful, and insisting that broader aspects of their tradition be opened to question and to exploration.

None of them breaks with tradition, and some will find them "conservative" because of this; but all break with convention, at least with recent convention, in wanting an art that tells of more experiences and emotions, even at the risk of eclecticism or recklessness, or even of conservatism itself. They are by no means alone in this, and their work on paper by no means tells the whole story of what they do. But in changing their expectation of art in general, they have changed our understanding of what contemporary drawing is like. If from this exhibition it seems less pure and independent an art than it recently had become, it is also a richer, more complex, and more inclusive one.

John Elderfield

JAKE BERTHOT

DAN CHRISTENSEN

ALAN COTE

TOM HOLLAND

YVONNE JACQUETTE

KEN KIFF

JOAN SNYDER

WILLIAM TUCKER

**B**orn 1939, Niagara Falls, New York. Attended Pratt Institute, Brooklyn, 1960-62; New School for Social Research, New York, 1960-61. Lives in New York City and Maine.

Individual Exhibitions

1970 O.K. Harris Gallery, New York (also 1972, 1975)

1971 Michael Walls Gallery, San Francisco

1973 Portland Center for the Visual Arts, Oregon; Galerie de Gestlo, Hamburg, West Germany (also 1977); Cuningham-Ward Gallery, New York

1974 Locksley-Shea Gallery, Minneapolis

1975 Daniel Weinberg Gallery, San Francisco

1976 David McKee Gallery, New York (also 1978)

1979 Nigel Greenwood Gallery, London; Nina Nielsen Gallery, Boston

Selected Group Exhibitions

1972 "Eight New York Painters," University of California Art Museum, Berkeley

1973 "Annual Exhibition," Whitney Museum of American Art, New York; "Paris Biennale," Paris

1974 "Continuing Abstraction in American Art," Whitney Museum of American Art, New York

1976 "Venice Biennale," U.S. Pavilion, Venice

1978 "8 Abstract Painters," Institute of Contemporary Art, Philadelphia; "American Art 1950 to Present," Whitney Museum of American Art, New York

1979 "New Painting — New York," Arts Council of Great Britain, Hayward Gallery, London

1980 "L'Amérique aux Indépendants 1944-1980," Grand Palais, Paris

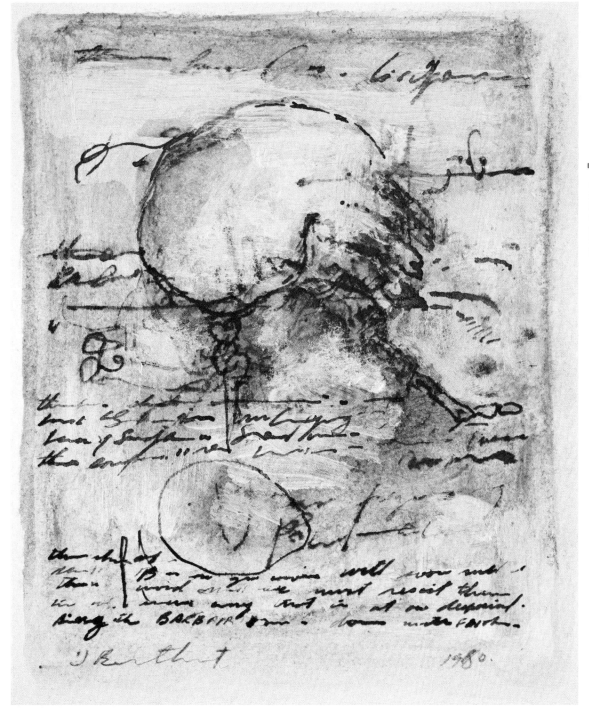

**Jake Berthot.** *Untitled (Skull).* 1980. Pen and ink, brush, ink wash, and enamel on gesso ground, 5¾ x 4¾″ (14.6 x 12.0 cm). Collection of the artist

**Jake Berthot.** *Untitled (Skull).*
1979. Pastel, brush, ink wash,
and enamel. 30 x 22″ (76.2 x
56.0 cm). Collection Thomas S.
Schultz, M.D., Boston

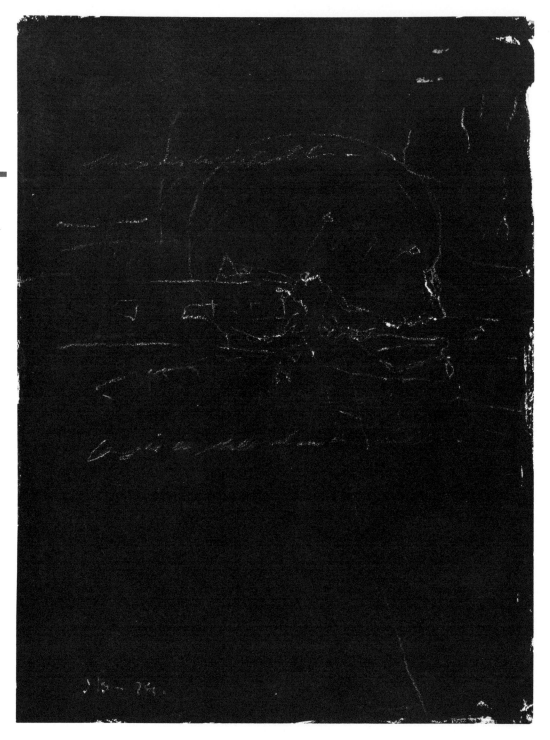

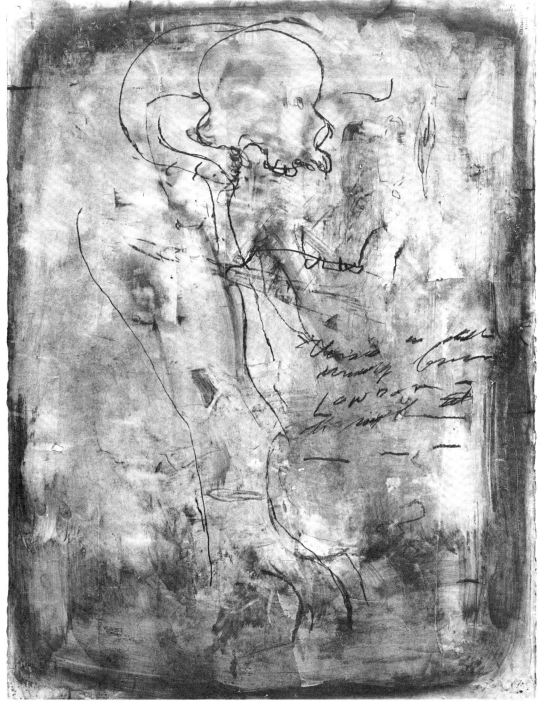

**Jake Berthot.** *Skull Group No. II: Drawing II.* 1979. Graphite, brush, ink wash, and enamel on gesso ground, 30 x 22¼″ (76.2 x 56.5 cm). Collection John Walker, London

Born 1942, Lexington, Nebraska. Received B.F.A. from Kansas City Art Institute, Missouri, 1964. Lives in New York City.

Individual Exhibitions

1967 Noah Goldowsky Gallery, New York (also 1968)

1968 Galerie Ricke, Cologne (also 1971)

1969 André Emmerich Gallery, New York (also 1971, 1972, 1974, 1975, 1976)

1970 Nicholas Wilder Gallery, Los Angeles (also 1972)

1973 Edmonton Art Gallery, Edmonton, Alberta, Canada

1974 Greenberg Gallery, St. Louis

1977 B.R. Kornblatt Gallery, Baltimore; Waton/de Nagy Gallery, Houston

1978 Douglas Drake Gallery, Kansas City, Kansas; Gloria Luria Gallery, Bay Harbor Islands, Florida (also 1980); Meredith Long and Company, Houston (also 1979, 1980); Meredith Long Contemporary, New York (also 1980)

1980 The University of Nebraska at Omaha Art Gallery, Omaha

Selected Group Exhibitions

1968 "Recent Acquisitions," Whitney Museum of American Art, New York

1969 "Here and Now," Washington University Gallery of Art, St. Louis

1970 "Color," Katonah Gallery, Katonah, New York

1971 "Color and Field 1890-1970," Albright-Knox Museum, Buffalo; "Lyrical Abstraction," Whitney Museum of American Art, New York

1972 "Abstract Painting of the 70s," The Boston Museum of Fine Arts, Boston

1973 "Annual Exhibition," Whitney Museum of American Art, New York

1974 "Contemporary American Colorfield Painting," Douglas Drake Gallery, Kansas City, Kansas

1977 "New Abstract Art," Edmonton Art Gallery, Edmonton, Alberta, Canada

1978 "Expressionism in the 70s," University of Nebraska, Omaha

**23**

**Dan Christensen.** *Untitled (No. 008-78).* 1978. Acrylic, 31 x 22½″ (78.7 x 57.1 cm). Salander-O'Reilly Galleries, New York

**Dan Christensen.** *Untitled (No. 003-78).* 1978. Acrylic on colored paper, 31½ x 22⅞" (80.0 x 58.1 cm). The Museum of Modern Art, New York. Gift of Mrs. Frank Y. Larkin

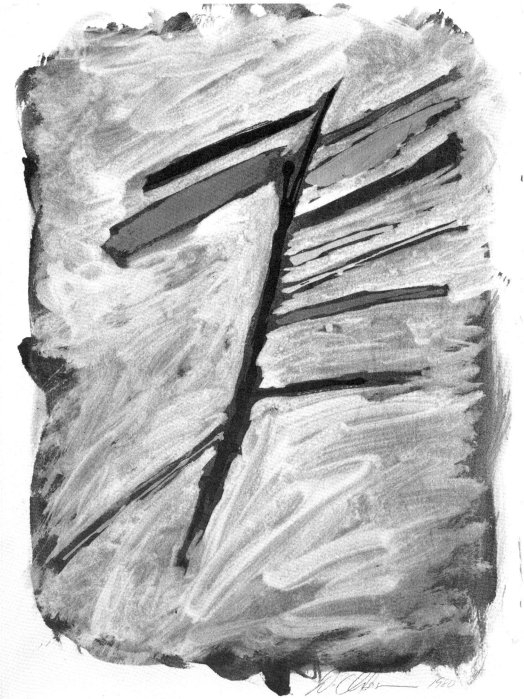

**Dan Christensen.** *Untitled (No. A015-80).* 1980. Acrylic, 30⅛ x 23¼″ (76.5 x 59.0 cm). Douglas Drake Gallery, Kansas City, Kansas

# ALAN COTE

Born 1937, Connecticut. Attended School of the Museum of Fine Arts, Boston, 1955-60. Fellowship from the Museum of Fine Arts, Boston, for travel and study in Europe, 1961-64. Lives in New York State.

Individual Exhibitions

1970  Galerie Ricke, Cologne (also 1972); Reese Palley Gallery, New York

1972  Dunkelman Gallery, Toronto

1973  Cuningham-Ward Gallery, New York (also 1974, 1975, 1977); Jared Sable Gallery, Toronto (also 1974)

1979  Betty Cuningham Gallery, New York (also 1980)

Selected Group Exhibitions

1969  Helman Gallery, St. Louis

1971  "Four Painters," Dallas Museum of Fine Arts, Dallas

1972  Richard Gray Gallery, Chicago

1973  "Drawings," Whitney Museum of American Art, New York

1974  "Painting and Sculpture Today," Indianapolis Museum, Indianapolis

1975  "Biennial Exhibition," Corcoran Gallery of Art, Washington, D.C.

1977  "Recent Works on Paper by American Artists," The Madison Art Center, Madison

1978  "New York Artists," Swearingen Gallery, Louisville

1979  "New Painting — New York," Arts Council of Great Britain, Hayward Gallery, London

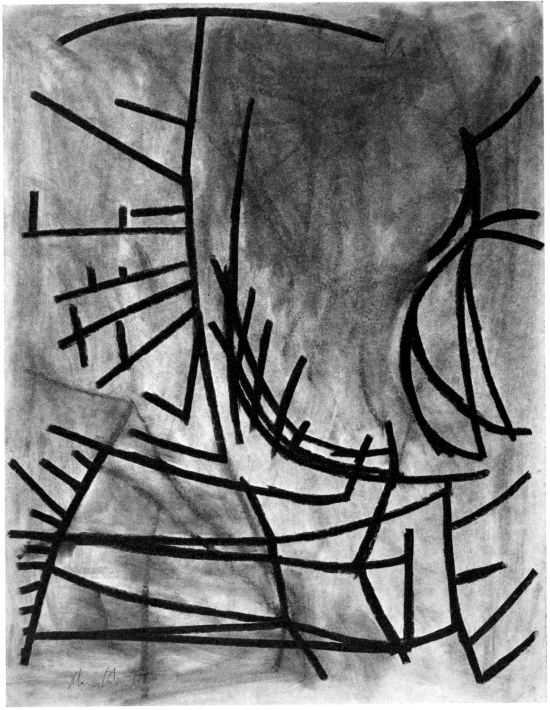

**Alan Cote.** *Bright Light.*
1980. Charcoal, 50 x 38½″
(127.0 x 97.8 cm). Betty
Cuningham Gallery, New York

**28**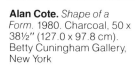

**Alan Cote.** *Shape of a Form.* 1980. Charcoal, 50 x 38½″ (127.0 x 97.8 cm). Betty Cuningham Gallery, New York

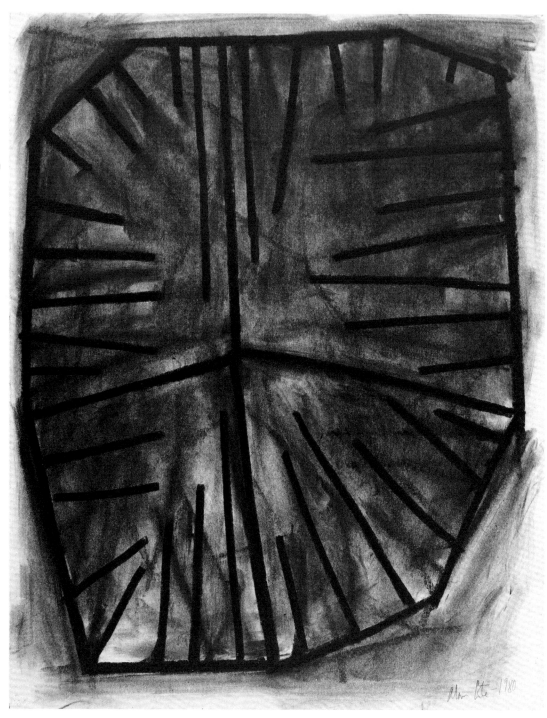

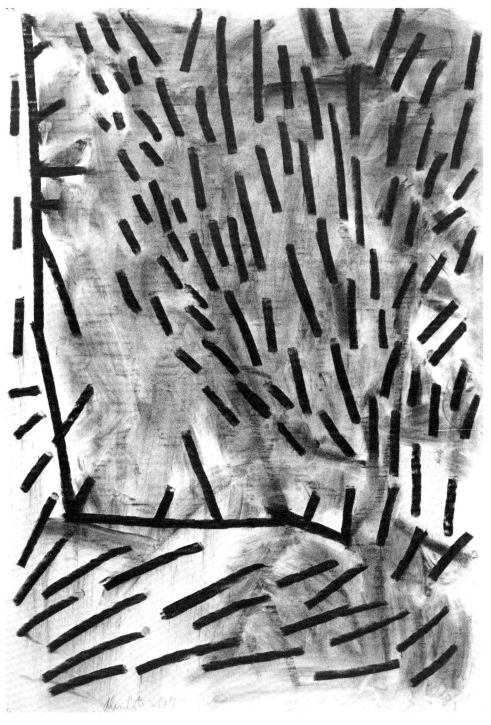

**Alan Cote.** *Light Near a Corner.* 1979.
Charcoal, 43¼ x 29½″ (109.9 x 75.0 cm).
Betty Cuningham Gallery, New York

# TOM HOLLAND

Born 1936, Seattle. Attended Willamette University, Salem, Oregon; University of California at Santa Barbara; and University of California at Berkeley. Lives in Berkeley.

Individual Exhibitions

1961 Catholic University, Santiago, Chile

1962 Richmond Art Center, Richmond, California (also 1966, 1975)

1963 Lanyon Gallery, Palo Alto, California (also 1964, 1965)

1965 Nicholas Wilder Gallery, Los Angeles (also 1967, 1968, 1969, 1972, 1973, 1975, 1976, 1977, 1979)

1966 Hansen Fuller Gallery, San Francisco (also 1968, 1970, 1972, 1973, 1974, 1976, 1977, 1980)

1968 Arizona State University, Tempe, Arizona

1970 Helman Gallery, St. Louis; Neuendorf Gallery, Hamburg; Robert Elkon Gallery, New York (also 1971)

1972 Corcoran and Corcoran Gallery, Miami; Multiples, Los Angeles

1973 Felicity Samuel, London; Knoedler Gallery, New York; Current Editions, Seattle

1975 "Prints and Drawings," Knoedler Contemporary Art, New York; Dootson/Calderhead Gallery, Seattle; Creigh Gallery, San Diego

1977 Waton/de Nagy Gallery, Houston (also 1979)

1978 Smith Anderson Gallery, Palo Alto, California; Charles Casat Gallery, La Jolla, California; Droll Kolbert Gallery, New York

1979 San Francisco Art Institute, San Francisco; Linda Farris Gallery, Seattle; Blum/Helman Gallery, New York

1980 Grossmonte College, San Diego; James Corcoran Gallery, Los Angeles

Selected Group Exhibitions

1964 "Bay Area Artists," San Francisco Art Institute, San Francisco

1965 "California Painters Invitational," Austin Museum, Austin

1966 "Art for Children," Los Angeles County Museum, Los Angeles

1967 "Grotesque Images," San Francisco Art Institute, San Francisco

1968 Philadelphia Academy of Arts Invitational, Philadelphia

1969 "Biennial Exhibition," Corcoran Gallery of Art, Washington, D.C. (also 1975)

1970 "Annual Exhibition," Whitney Museum of American Art, New York

1972 "California Prints," The Museum of Modern Art, New York

1977 National Collection of Fine Arts, Washington, D.C.

1978 "New Acquisitions," Whitney Museum of American Art, New York

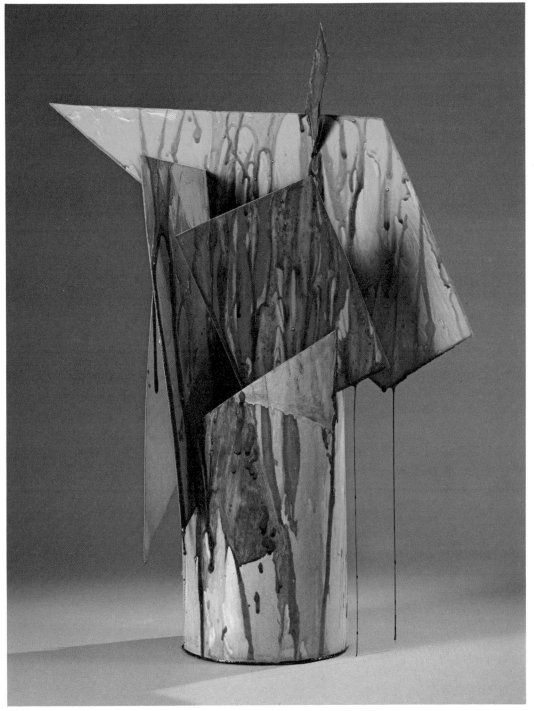

**Tom Holland.** *F.S. No. 2.* 1980.
Epoxy on paper, 20¾ x 15 x 9½″
(52.7 x 38.1 x 24.1 cm). Hansen
Fuller Goldeen Gallery, San
Francisco

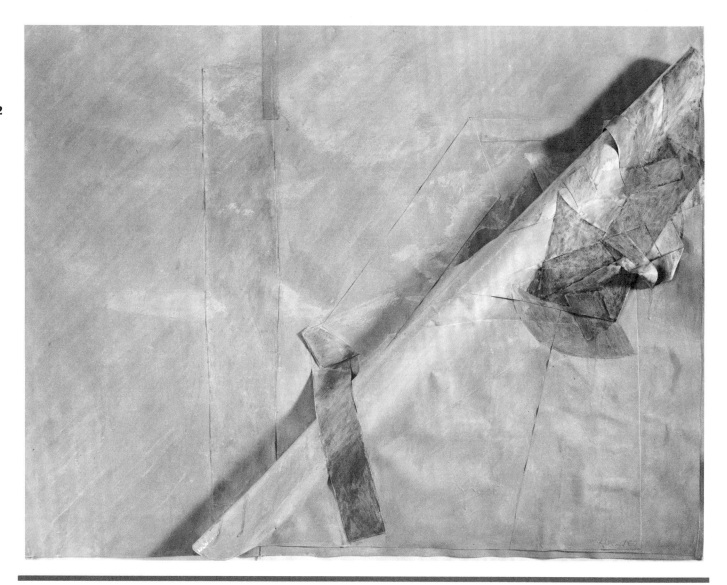

Above: **Tom Holland.** *Dome Series No. 23.* 1980. Epoxy on paper, 35 x 46 x 2″ (88.8 x 106.9 x 5.1 cm). Hansen Fuller Goldeen Gallery, San Francisco

Opposite: **Tom Holland.** *F.S. No. 5.* 1980. Epoxy on paper, 19½ x 19 x 7″ (49.5 x 48.2 x 17.8 cm). Blum/Helman Gallery, New York

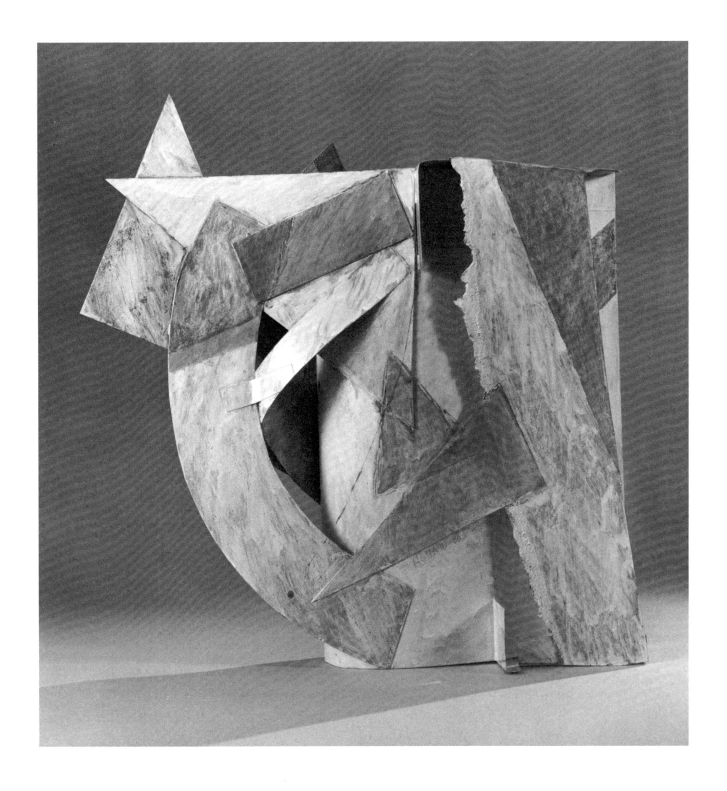

**B**orn 1934, Pittsburgh. Studied at Rhode Island School of Design, Providence, 1952-56. Lives in New York and Morril, Maine.

Individual Exhibitions
1965  Swarthmore College, Swarthmore, Pennsylvania
1971  Fischbach Gallery, New York (also 1974)
1972  Tyler School Art Gallery, Philadelphia
1974  Brooke Alexander, Inc., New York (also 1976, 1979)

Selected Group Exhibitions
1970  "Contemporary American Painting and Sculpture,"
       Wilmington Society of Fine Arts, Wilmington, Delaware
1971  "American Art Attack," Amsterdam
1972  "Annual Exhibition," Whitney Museum of American Art, New York

1973  "New York Realism," Espace Cardein, Paris
1974  "New Images in Painting," International Biennale, Tokyo
1975  "Small Scale in Contemporary Art," Art Institute of
       Chicago, Chicago
1976  "The Year of the Woman: Reprise," Bronx Museum, New York
1977  "Contact: Women and Nature," Hurlbutt Gallery, Greenwich,
       Connecticut
1978  "Couples Show," P.S. 1; organized by the Institute for Art
       and Urban Resources, New York
1979  "Figurative/Realist Art," a benefit exhibition for the Artists'
       Choice Museum, New York
1980  "Large Drawings/Yvonne Jacquette, Alex Katz, Ann McCoy,
       Theo Wujcik," Brooke Alexander, Inc., New York

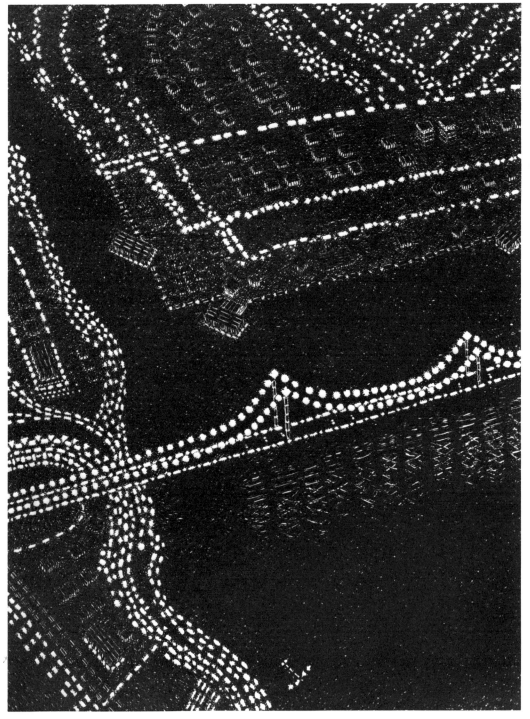

**Yvonne Jacquette.** *Verrazano Composite I.* (1980). Oil crayon on composition board, 64 x 48″ (162.5 x 121.9 cm). Brooke Alexander, Inc., New York

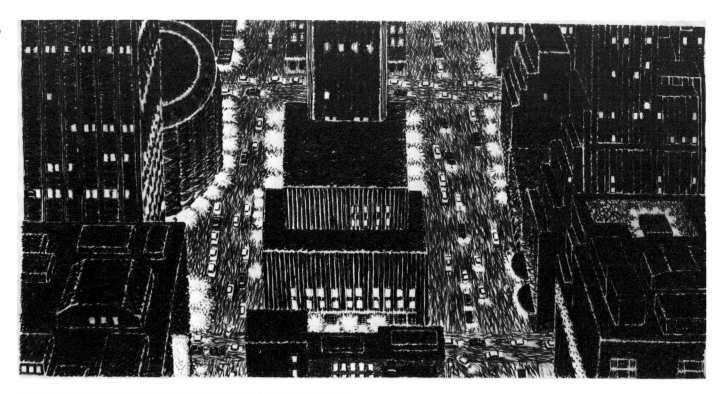

**Yvonne Jacquette.** *Aerial View of 34th Street.* (1979). Pastel on plastic vellum, 37¾ x 74" (95.9 x 188.0 cm). Collection Malcolm Goldstein, New York

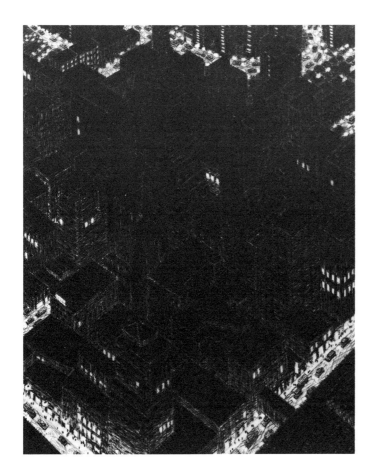 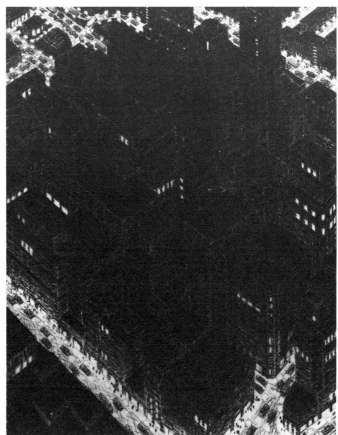

**Yvonne Jacquette.** *Diptych: Two Views from the Empire State Building.* (1980). Pastel on plastic vellum, 47 x 37½″ each (119.4 x 95.2 cm. each). The Museum of Modern Art, New York. Gift of Lily vA. Auchincloss.

Born 1935, Dagenham, Essex, England. Attended the Hornsey School of Art, Surrey, England, 1955-61. Lives and works in Wimbledon, London.

Individual Exhibitions
1975  Serpentine Gallery, London
1979  Gardner Art Center, Sussex University, Brighton, England
1980  Nicola Jacobs Gallery, London

Selected Group Exhibitions
1970  "Critic's Choice," Arthur Tooth & Sons, London

1973  "Magic and Strong Medicine," Walker Art Gallery, Liverpool; "Contemporary British Art," Rochdale, England
1974  "British Watercolours," Rochdale, England
1975  "Painters of Reality, Mystery and Illusion," Rochdale, England
1976  "Body and Soul," Walker Art Gallery, Liverpool
1979  "Narrative Painting," Arnolfini, Bristol, England
1980  "The First Exhibition," Nicola Jacobs Gallery, London; "Works on Paper," Nicola Jacobs Gallery, London

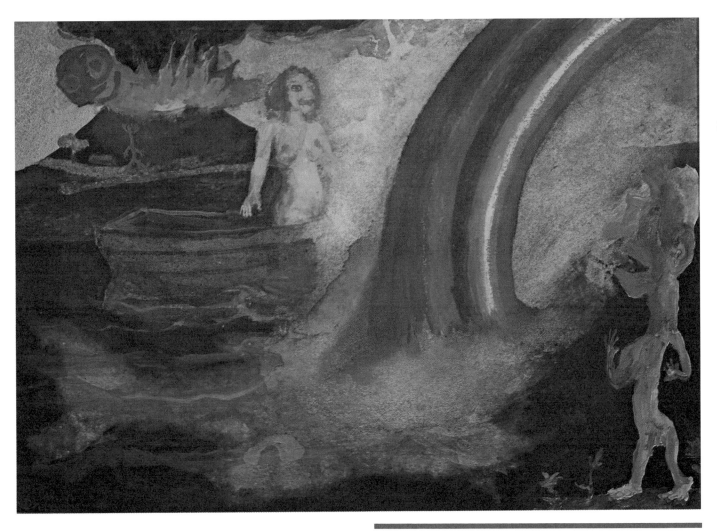

**Ken Kiff.** *Rainbow and Boat.* (1978). Watercolor, 7¼ x 10½″ (18.4 x 26.7 cm). Private collection, London

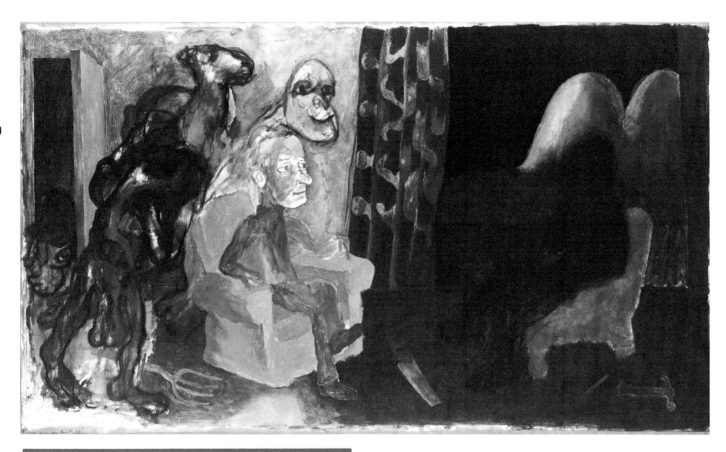

**Ken Kiff.** *Sequence 113: Talking with a Psychoanalyst: Night Sky.*
(1975-80). Acrylic, 30¾ x 53½″ (78.1 x 135.9 cm). Collection Edward
Wolf, Esq., London

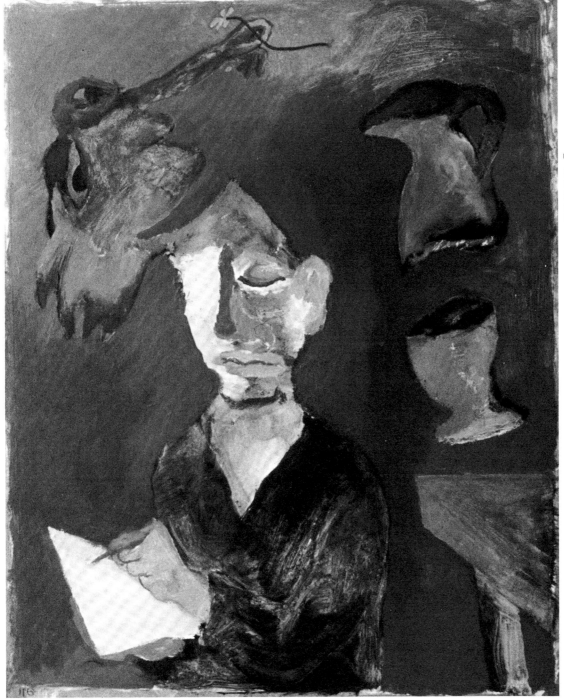

**Ken Kiff.** *Sequence 116: Broken Jug.* (1975). Acrylic, 23¼ x 18½″ (59.0 x 47.0 cm). Nicola Jacobs Gallery, London

Born 1940, Highland Park, New Jersey. Attended Douglass College, New Brunswick, New Jersey, 1958-62; received M.F.A. from Rutgers University, New Jersey, 1966. Currently resides and works in New York City.

Individual Exhibitions

1971  Michael Walls Gallery, San Francisco; Paley and Lowe Gallery, New York (also 1973)

1972  Douglass College, New Brunswick, New Jersey; Parker 470 Gallery, Boston

1976  Carl Solway Gallery, New York; Reed College, Portland, Oregon; Portland Center for the Visual Arts, Portland, Oregon; Los Angeles Institute of Contemporary Art, Los Angeles

1977  Wake Forest University, Winston-Salem, North Carolina

1978  Neuberger Museum, Purchase, New York; Hamilton Gallery of Contemporary Art, New York

Selected Group Exhibitions

1971  "Into the 70s," Mansfield Fine Arts Museum, Mansfield, Ohio

1972  "Annual Exhibition," Whitney Museum of American Art, New York; "Grids," Institute of Contemporary Art, Philadelphia

1973  "New York Avant-Garde," Saidye Bronfman Center, Montreal

1974  "Women's Work — American Art '74," Philadelphia Civic Center, Philadelphia

1975  "Biennial Exhibition," Corcoran Gallery of Art, Washington, D.C.

1976  "23 American Women Artists," Mary McKay Koogler Art Institute, San Antonio

1977  "Contemporary Women: Consciousness and Content," Brooklyn Museum, New York; "Drawing on a Grid," Susan Caldwell Gallery, New York; "Twelve from Rutgers," University Art Gallery, Rutgers University, New Brunswick, New Jersey

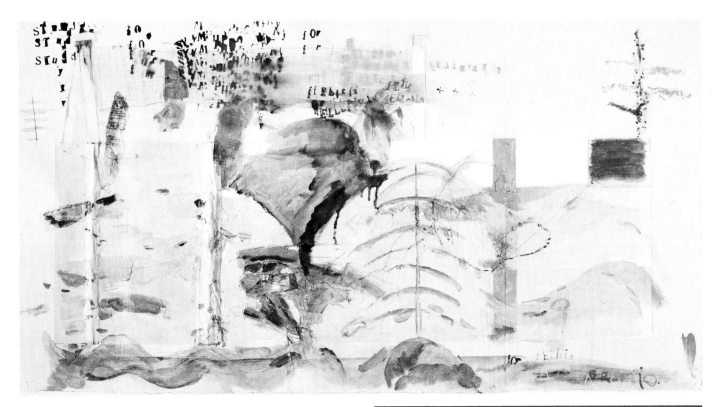

**Joan Snyder.** *Study for Symphony for Felicia.* (1978). Pastel, watercolor, graphite, beads, and thread. 22½ x 42″ (57.2 x 106.7 cm). Collection Felicia Sachs, New York

44

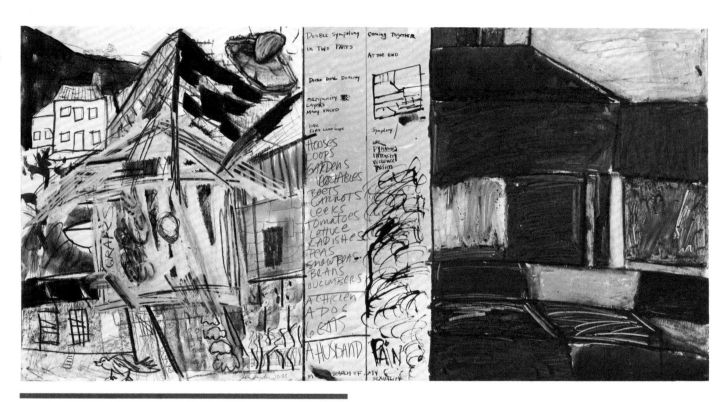

**Joan Snyder.** *Double Symphony.* (1976). Oil crayon, ink, graphite, and gesso on cardboard, 16 x 31⅞" (40.6 x 81.0 cm). Collection of the artist

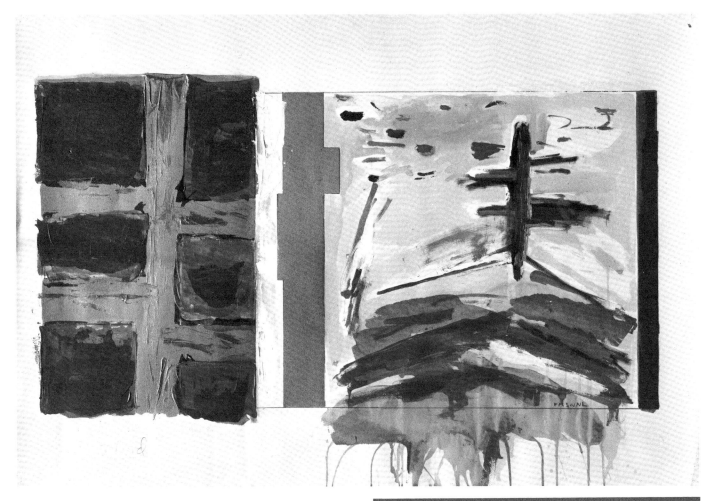

**Joan Snyder.** *Study for FMSWNL.* (1980). Paint on lithographic proof, 25½ x 37¼″ (64.8 x 94.6 cm). Collection of the artist

Born 1935, Cairo. Attended Oxford University, 1955-58. Studied sculpture at Central School of Art and Design and St. Martin's School of Art, London, 1959-60. Lives in New York.

Individual Exhibitions

1962 Grabowski Gallery, London

1965 Richard Feigen Gallery, New York

1966 Rowan Gallery, London (also 1973)

1967 Kasmin Gallery, London (also 1969, 1977)

1968 Robert Elkon Gallery, New York (also 1977)

1969 Leeds City Art Gallery (Gregory Fellow Exhibition); Leslie Waddington Prints, Ltd., London

1972 "Venice Biennale," Venice

1973 Hamburg Kunstverein, Bochum, West Germany; Serpentine Gallery, London; Waddington Gallery, London; Hester van Royen Gallery, London

1976 Galerie Wintersberger, Cologne

1978 Retrospective Exhibition, Fruit Market Gallery, Edinburgh (sponsored by the British Arts Council); Sable-Castelli Gallery, Toronto

Selected Group Exhibitions

1961 "Twenty-six Young Sculptors," Institute of Contemporary Arts, London

1965 "New Generation 1965," Whitechapel Gallery, London

1966 "Primary Structures," The Jewish Museum, New York

1968 "Documenta IV," Kassel, West Germany

1971 "British Painting and Sculpture, 1960-61," National Gallery of Art, Washington, D.C.

1975 "The Condition of Sculpture," Arts Council of Great Britain, Hayward Gallery, London

1976 "The Biennale of Sydney," Art Gallery of New South Wales, Sydney

1979 "Contemporary Sculpture," The Museum of Modern Art, New York

1980 "Drawings by Three Artists," Betty Cuningham Gallery, New York; "Contemporary British Painting and Sculpture," Museum of Modern Art, Tokyo; "The International Sculpture Conference," Washington, D.C.

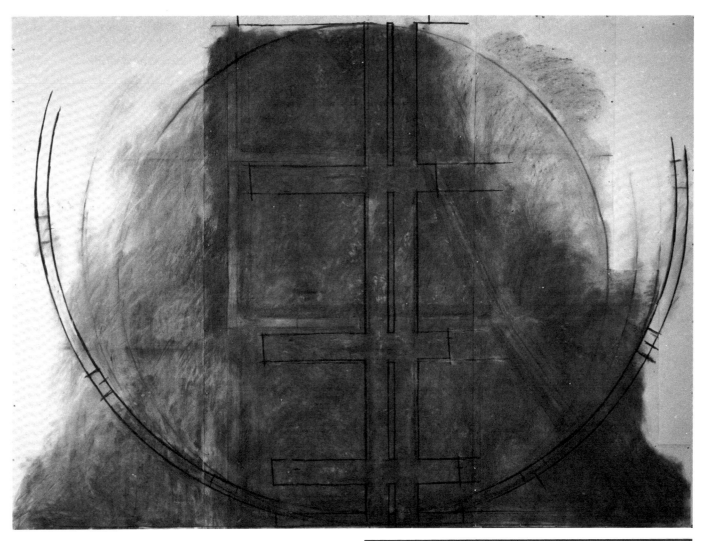

**William Tucker.** *The Rim, first drawing.* (1979-80). Charcoal, 11'1¼" x 14'10¼" (338.5 x 452.8 cm). The Museum of Modern Art, New York. The Louis and Bessie Adler Foundation Fund, Seymour M. Klein, President.

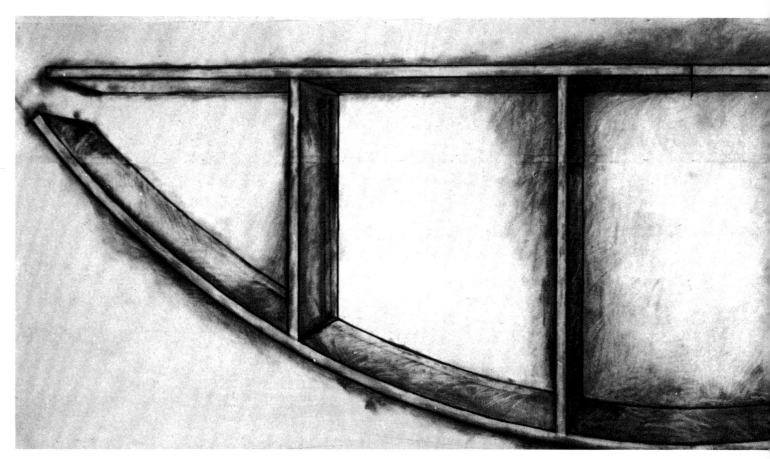

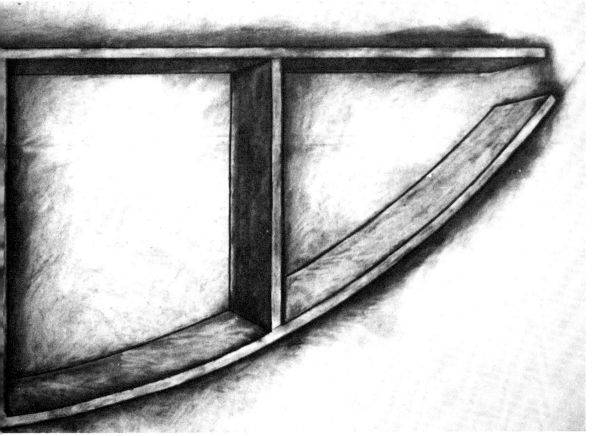

**William Tucker.** *Arc with Lintel.*
(1978). Charcoal, 8'8⅝" x 29'11"
(265.8 x 911.9 cm). Robert Elkon
Gallery, New York

# CHECKLIST OF THE EXHIBITION

In the listings below, dates enclosed in parentheses do not appear on the works themselves. Sheet dimensions are given in inches and centimeters, height preceding width. Depth is also included where relevant. Unless otherwise noted all works are on white paper.

## JAKE BERTHOT

*Skull No. 3.* (1977). Oil crayon, brush and enamel on gesso ground, 30 x 22½" (76.2 x 57.2 cm). Collection Mr. and Mrs. S. I. Newhouse, Jr., New York

*Skull No. 4.* (1977). Oil crayon, brush and enamel on gesso ground, 30 x 22½" (76.2 x 57.2 cm). Collection Mr. and Mrs. S. I. Newhouse, Jr., New York

*Skull No. 5.* (1977). Oil crayon, brush and enamel on gesso ground, 30 x 22½" (76.2 x 57.2 cm). Collection Mr. and Mrs. S. I. Newhouse, Jr., New York

*Skull No. 7.* (1977). Oil crayon, brush, ink wash, and enamel on gesso ground, 30 x 22½" (76.2 x 57.2 cm). Collection Mr. and Mrs. S. I. Newhouse, Jr., New York

*Skull Group No. II: Drawing I.* 1979. Graphite, brush, ink wash, enamel, and oil crayon on gesso ground, 30 x 22⅝" (76.2 x 57.4 cm). Private collection, London

*Skull Group No. II: Drawing II.* 1979. Graphite, brush, ink wash, and enamel on gesso ground, 30 x 22¼" (76.2 x 56.5 cm). Collection John Walker, London

*Untitled (Skull).* 1979. Pastel, brush, ink wash, and enamel, 30 x 22" (76.2 x 56.0 cm). Collection Thomas S. Schultz, M.D., Boston

*Untitled (Skull).* 1979. Pastel, brush, ink wash, and enamel, 30 x 22" (76.2 x 55.9 cm). Collection Thomas S. Schultz, M.D., Boston

*Untitled (Skull).* 1980. Pen and ink, brush, ink wash, and enamel on gesso ground, 12¼ x 11¾" (31.1 x 29.8 cm). David McKee Gallery, New York

*Untitled (Skull).* 1980. Pen and ink, brush, ink wash, and enamel on gesso ground, 11¼ x 11¾" (28.6 x 29.8 cm). Collection Lois E. Dickson, New Jersey

*Untitled (Skull).* 1980. Graphite, pen and ink, brush, ink wash, and enamel on gesso ground, 6⅝ x 5⅜" (16.7 x 13.7 cm). The Museum of Modern Art, New York. The Louis and Bessie Adler Foundation Fund, Seymour M. Klein, President

*Untitled (Skull).* 1980. Pen and ink, brush, ink wash, and enamel on gesso ground, 5¾ x 4¾" (14.6 x 12.0 cm). Collection of the artist

*Untitled (Skull).* 1980. Pen and ink, brush, ink wash, and enamel on gesso ground, 6⅛ x 5½" (15.5 x 14.0 cm). David McKee Gallery, New York

*Untitled (Skull).* 1980. Pen and ink, brush, ink wash, and enamel on gesso ground, 6 x 6⅛" (15.2 x 15.5 cm). David McKee Gallery, New York

*Untitled (Skull).* (1980). Pen and ink, brush, ink wash, and enamel on gesso ground, 5⅝ x 5⅜" (14.5 x 13.6 cm). David McKee Gallery, New York

## DAN CHRISTENSEN

*Untitled (No. 022-77).* 1977. Acrylic, watercolor, and gesso, 26⅝ x 16⅝" (67.6 x 42.2 cm). Meredith Long and Company, Houston

*Untitled (No. 003-78).* 1978. Acrylic on col-

ored paper, 31½ x 22⅞" (80.0 x 58.1 cm). The Museum of Modern Art, New York. Gift of Mrs. Frank Y. Larkin

*Untitled (No. 007-78).* 1978. Acrylic and gesso on colored paper, 23¼ x 31½" (59.0 x 80.0 cm). Salander-O'Reilly Galleries, New York

*Untitled (No. 008-78).* 1978. Acrylic, 31 x 22½" (78.7 x 57.1 cm). Salander-O'Reilly Galleries, New York

*Untitled (No. 017-78).* 1978. Acrylic and gesso, 22¾ x 29¾" (57.8 x 75.5 cm). Meredith Long and Company, Houston

*Untitled (No. 014-79).* 1979. Acrylic and watercolor, 29⅞ x 22¾" (75.9 x 57.8 cm). Meredith Long and Company, Houston

*Untitled (No. A004-80).* 1980. Acrylic, watercolor, and crayon, 29¾ x 22¾" (75.5 x 57.8 cm). Meredith Long and Company, Houston

*Untitled (No. A015-80).* 1980. Acrylic, 30⅛ x 23¼" (76.5 x 59.0 cm). Douglas Drake Gallery, Kansas City, Kansas

*Untitled (No. A018-80).* 1980. Acrylic, 21⅞ x 29⅞" (55.6 x 75.9 cm). Douglas Drake Gallery, Kansas City, Kansas

*Untitled (No. A021-80).* 1980. Acrylic, 27⅞ x 27½" (70.8 x 69.9 cm). Douglas Drake Gallery, Kansas City, Kansas

*Untitled (No. A043-80).* 1980. Acrylic and crayon, 30⅛ x 22⅝" (76.5 x 57.5 cm). Meredith Long and Company, Houston

*Untitled (No. A046-80).* (1980). Acrylic, 22¾ x 30⅛" (57.8 x 76.5 cm). Meredith Long and Company, Houston

*Untitled (No. A047-80).* 1980. Acrylic, 22½ x

30¼" (57.2 x 76.8 cm). Meredith Long and Company, Houston

**ALAN COTE**

*Enclose.* 1979. Charcoal, 41½ x 29¾" (105.4 x 75.5 cm). Betty Cuningham Gallery, New York

*Constructing a Corner.* 1979. Charcoal, 41½ x 29¾" (105.4 x 75.5 cm). Betty Cuningham Gallery, New York

*Light Near a Corner.* 1979. Charcoal, 43¼ x 29½" (109.9 x 75.0 cm). Betty Cuningham Gallery, New York

*Bright Light.* 1980. Charcoal, 50 x 38½" (127.0 x 97.8 cm). Betty Cuningham Gallery, New York

*Echo.* 1980. Charcoal, 50 x 38½" (127.0 x 97.8 cm). Betty Cuningham Gallery, New York

*Inner Direction.* 1980. Charcoal, 50 x 38½" (127.0 x 97.8 cm). Betty Cuningham Gallery, New York

*Left Wind.* 1980. Charcoal, 41½ x 29¾" (105.4 x 75.5 cm). Betty Cuningham Gallery, New York

*Shape of a Form.* 1980. Charcoal, 50 x 38½" (127.0 x 97.8 cm). Betty Cuningham Gallery, New York

*Three Sounds.* 1980. Charcoal, 40 x 26¼" (101.7 x 66.6 cm). Betty Cuningham Gallery, New York

**TOM HOLLAND**

*F. S. No. 1.* 1980. Epoxy on paper, 24¼ x 10 x 9" (61.6 x 25.4 x 22.9 cm). Hansen Fuller Goldeen Gallery, San Francisco

*F. S. No. 2.* 1980. Epoxy on paper, 20¾ x 15 x 9½" (52.7 x 38.1 x 24.1 cm). Hansen Fuller Goldeen Gallery, San Francisco

*F. S. No. 3.* 1980. Epoxy on paper, 22 x 9 x 7" (55.9 x 22.9 x 17.8 cm). Blum/Helman Gallery, New York

*F. S. No. 4.* 1980. Epoxy on paper, 23¼ x 18 x 8¾" (59.1 x 45.7 x 22.2 cm). Hansen Fuller Goldeen Gallery, San Francisco

*F. S. No. 5.* 1980. Epoxy on paper, 19½ x 19 x 7" (49.5 x 48.2 x 17.8 cm). Blum/Helman Gallery, New York

*F. S. No. 6.* 1980. Epoxy on paper, 19 x 15 x 7" (48.2 x 38.1 x 17.8 cm). Blum/Helman Gallery, New York

*F. S. No. 7.* 1980. Epoxy on paper, 30 x 15 x 12" (76.2 x 38.1 x 30.5 cm). Blum/Helman Gallery, New York

*F. S. No. 8.* 1980. Epoxy on paper, 34 x 35½ x 11" (86.3 x 90.2 x 27.9 cm). Hansen Fuller Goldeen Gallery, San Francisco

*Dome Series No. 23.* 1980. Epoxy on paper, 35 x 46 x 2" (88.8 x 106.9 x 5.1 cm). Hansen Fuller Goldeen Gallery, San Francisco

*Dome Series No. 24.* 1980. Epoxy on paper, 46 x 35 x 1" (106.9 x 88.8 x 2.6 cm). Hansen Fuller Goldeen Gallery, San Francisco

*Dome Series No. 25.* 1980. Epoxy on paper, 35 x 46 x 1¾" (89.0 x 106.9 x 4.4 cm). Blum/Helman Gallery, New York

*Dome Series No. 29.* 1980. Epoxy on paper, 46 x 35 x 2" (106.9 x 89.0 x 5.1 cm). Collection of the artist

*Dome Series No. 31.* 1980. Epoxy on paper, 46 x 35 x 3½" (106.9 x 88.8 x 8.8 cm). Blum/Helman Gallery, New York

**YVONNE JACQUETTE**

*Aerial View of 34th Street.* (1979). Pastel on plastic vellum, 37¾ x 74" (95.9 x 188.0 cm). Collection Malcolm Goldstein, New York

*Diptych: Two Views from the Empire State Building.* (1980). Pastel on plastic vellum, 47 x 37½" each (119.4 x 95.2 cm each). The Museum of Modern Art, New York. Gift of Lily vA. Auchincloss

*Newark Composite.* (1980). Pastel, 59 x 48" (149.8 x 121.9 cm). Brooke Alexander, Inc., New York

*Verrazano Composite I.* (1980). Oil crayon on composition board, 64 x 48" (162.5 x 121.9 cm). Brooke Alexander, Inc., New York

*Verrazano Composite II.* (1980). Charcoal, 58¾ x 48" (149.2 x 121.9 cm). Brooke Alexander, Inc., New York

*Color Pastel: Night Jet III–Verrazano Composite I.* (1979). Pastel on dark paper, 17¼ x 14" (43.8 x 35.6 cm). Brooke Alexander, Inc., New York

*Color Pastel: Night Jet IV–Boston Composite.* (1980). Pastel on dark paper, 17¼ x 14" (43.8 x 35.6 cm). Brooke Alexander, Inc., New York

*Color Pastel: Night Jet V–Newark Composite.* (1980). Pastel on dark paper, 17½ x 14" (44.4 x 35.6 cm). Brooke Alexander, Inc., New York

*Color Pastel: Night Jet VI–Verrazano Composite II.* (1980). Pastel on dark paper, 17 x 14¼" (43.2 x 36.2 cm). Brooke Alexander, Inc., New York

*Color Pastel: Queens Lights at Night.* (1980). Pastel on dark paper, 17 x 14½" (43.2 x 36.8 cm). Brooke Alexander, Inc., New York

*Color Pastel: Queens Lights at Night.* (1980). Pastel on dark paper, 17 x 14½" (43.2 x 36.8 cm). Brooke Alexander, Inc., New York

## KEN KIFF

*Sequence 3: Talking with a Psychoanalyst: A Crack in the Yellow.* (1971). Acrylic, 11½ x 15″ (29.2 x 38.1 cm). Private collection, London

*Sequence 68: Visiting Hell in a Boat.* (1973). Acrylic, 22½ x 29″ (57.1 x 73.6 cm). Nicola Jacobs Gallery, London

*Sequence 110: Man and Street.* (1975). Acrylic, 28¾ x 22⅞″ (73.0 x 58.1 cm). Nicola Jacobs Gallery, London

*Sequence 113: Talking with a Psychoanalyst: Night Sky.* (1975-80). Acrylic, 30¾ x 53½″ (78.1 x 135.9 cm). Collection Edward Wolf, Esq., London

*Sequence 116: Broken Jug.* (1975). Acrylic, 23¼ x 18½″ (59.0 x 47.0 cm). Nicola Jacobs Gallery, London

*Sequence 125: Large Face.* (1976). Acrylic, 31¼ x 22¼″ (79.4 x 56.5 cm). Nicola Jacobs Gallery, London

*Sequence 127: The Ascent.* (1976-80). Acrylic, 47 x 31″ (119.4 x 78.7 cm). Nicola Jacobs Gallery, London

*Sequence 135: Night Clouds.* (1977). Acrylic, 22¾ x 28¾″ (57.8 x 73.0 cm). Nicola Jacobs Gallery, London

*Sequence 138: Breaking a Barrier.* (1977). Acrylic, 19¼ x 28¾″ (48.9 x 73.0 cm). Nicola Jacobs Gallery, London

*Sequence 162: The Epileptic.* (1980). Acrylic, 22⅝ x 28⅞″ (57.5 x 73.3 cm). Nicola Jacobs Gallery, London

*Sequence 167: Giraffe and People.* (1980). Acrylic, 29 x 22½″ (73.6 x 57.1 cm). Nicola Jacobs Gallery, London

*Rainbow and Boat.* (1978). Watercolor, 7¼ x 10½″ (18.4 x 26.7 cm). Private collection, London

*The Island.* (1979). Watercolor, 8 x 6¼″ (20.3 x 15.9 cm). Nicola Jacobs Gallery, London

*Two Heads and the Sea.* (1979). Watercolor, 5¼ x 7″ (13.3 x 17.8 cm). Nicola Jacobs Gallery, London

*Drawing a Curtain and Tortoise.* (1980). Watercolor, 6¼ x 7″ (15.9 x 17.8 cm). Nicola Jacobs Gallery, London

*Head, House and Hill.* (1980). Watercolor, 6¼ x 4¾″ (15.9 x 12.1 cm). Nicola Jacobs Gallery, London

*Pink Head.* (1980). Watercolor, 6½ x 4¾″ (16.5 x 12.1 cm). Nicola Jacobs Gallery, London

## JOAN SNYDER

*Double Symphony.* (1976). Oil crayon, ink, graphite, and gesso on cardboard, 16 x 31⅞″ (40.6 x 81.0 cm). Collection of the artist

*Untitled.* (1976). Oil, pastel, crayon, colored pencil, and graphite, 22½ x 30″ (57.2 x 76.2 cm). Hamilton Gallery of Contemporary Art, New York

*Beginning Study for Symphony for Felicia.* (1978). Watercolor and graphite, 10¼ x 19¾″ (26.0 x 50.2 cm). Collection of the artist

*Watercolor Study for Symphony for Felicia.* (1978). Pastel, watercolor, graphite, and beads, 10¼ x 19¾″ (26.0 x 50.2 cm). Collection of the artist

*Detail for Symphony for Felicia.* (1978). Acrylic, watercolor, and beads, 10¼ x 9¾″ (26.0 x 24.8 cm). Collection of the artist

*Detail for Symphony for Felicia.* (1978).

Watercolor, stamp and ink, and jewels, 10¼ x 10¼″ (26.0 x 26.0 cm). Collection Patricia Hamilton, New York

*Study for Symphony for Felicia.* (1978). Pastel, watercolor, graphite, beads, and thread, 22½ x 42″ (57.2 x 106.7 cm). Collection Felicia Sachs, New York

*Study for Norfolk Landscape.* (1978). Watercolor, 8¾ x 19″ (22.2 x 48.2 cm). Collection Donna Sands, Pennsylvania

*Untitled.* (1979). Watercolor and graphite, 11⅛ x 19⅞″ (28.2 x 50.5 cm). Collection of the artist

*Untitled.* (1980). Oil, watercolor, gouache, papier-maché, graphite, and glitter, 22 x 70″ (59.8 x 170.8 cm). Hamilton Gallery of Contemporary Art, New York

*Study for FMSWNL.* (1980). Paint on lithographic proof in two sections, 24 x 34¾″ (61.0 x 85.7 cm). Collection of the artist

*Study for FMSWNL.* (1980). Paint on lithographic proof, 24 x 36½″ (60.9 x 92.7 cm). Collection of the artist

*Study for FMSWNL.* (1980). Paint on lithographic proof, 25½ x 37¼″ (64.8 x 94.6 cm). Collection of the artist

## WILLIAM TUCKER

*Arc with Lintel.* (1978). Charcoal, 8'8⅝″ x 29'11″ (265.8 x 911.9 cm). Robert Elkon Gallery, New York

*The Rim, first drawing.* (1979-80). Charcoal, 11'1¼″ x 14'10¼″ (338.5 x 452.8 cm). The Museum of Modern Art, New York. The Louis and Bessie Adler Foundation Fund, Seymour M. Klein, President

# BIBLIOGRAPHY

## JAKE BERTHOT

Ashton, Dore. "Young Abstract Painters: Right On!" *Arts* 44 (February 1970): 34.

Davis, Douglas. "The New Color Painters." *Newsweek*, May 4, 1970.

Shirey, David L. "Downtown Scene: Heart." *The New York Times*, September 12, 1970.

Sharp, Willoughby. "Points of View: A Taped Conversation with Four Artists." *Arts* 45 (December 1970): 41-42.

Ashton, Dore. "New York Commentary: Downtown, Uptown, All around the Town." *Studio International* 181 (January 1971): 39.

Baker, Kenneth. "O.K. Harris Gallery, New York, exhibit." *Artforum* 9 (February 1971): 81.

Domingo, Willis. "O.K. Harris Gallery, New York, exhibit." *Arts* 45 (February 1971): 55.

Ratcliff, C. "O.K. Harris Gallery, New York, exhibit." *Art International* 15 February 1971): 69.

Ashton, Dore. "Jake Berthot Paints Quietness." *Arts* 46 (November 1971): 32-35.

Goldberg, Lenore. "A Renewal of Possibilities." *Arts* 47 (March 1973): 34-35.

Beret, Chantal. "Jake Berthot: 8e Biennale." *Artpress*, Paris, September 1973.

Ashton, Dore. "Jake Berthot." *Arts* 48 (June 1974): 33-34.

Plagens, Peter. "Peter and the Pressure Cooker." *Artforum* 13 (June 1974): 86-87.

Locksley Shea Gallery, Minneapolis, Minnesota. "Jake Berthot." Catalog, 1974.

Hunter, Sam. "Critical Perspectives in American Art." Venice Biennale, 1976. Catalog.

Ashton, Dore. "Eight Abstract Painters." Institute of Contemporary Art, Philadelphia, Pennsylvania.

Karson, Robin. "Silence and Slow Time." Mount Holyoke College Art Museum, South Hadley, Massachusetts, 1977.

Saulnier, Bonnie. "From Women's Eyes." Brandeis University, Waltham, Massachusetts. Catalog, 1977.

Kasher, Steven. "Jake Berthot: Recent Work." *Artforum* 17 (September 1978): 68-73.

Ashton, Dore. "David McKee Gallery, New York, exhibit." *Arts* 53 (January 1979): 2.

Brach, P. "David McKee Gallery, New York, exhibit." *Art in America* 67 (January 1979): 142.

Maschek, Joseph. "Pictures of Art." *Artforum* 18 (May 1979): 35-36.

## DAN CHRISTENSEN

Rose, B. "Gallery Without Walls." *Art in America* 56 (March 1968): 71.

Wasserman, Emily. "Corcoran Biennial, Corcoran Gallery, Washington D.C." *Artforum* 7 (April 1969): 71-74.

Glueck, Grace. "Like a Beginning." *Art in America* 57 (May/June 1969): 118-19.

"Painting — Dervish Loops." *Time*, May 30, 1969, p. 64.

"Art in New York, Midtown, Dan Christensen." *Time*, June 6, 1969, p. 2.

Gruen, John. "The Whoosh is the Work." *New York Magazine*, June 9, 1969, p. 57.

Davis, Douglas. "This is the Loose-Paint Generation." *The National Observer*, August 4, 1969, p. 20.

The Solomon R. Guggenheim Museum, New York. *Nine Young Theodoran Awards*, "Dan Christensen." Summer 1969.

Aldrich, Larry. "Young Lyrical Painters." *Art in America* 57 (November/December 1969): 104-13.

Ratcliff, Carter. "The New Informalists." *Art News* 68 (February 1970): 46-50.

Colt, Priscilla. "Some Recent Acquisitions of Contemporary Painting." *The Dayton Art Institute Bulletin* 2 28 (March 1970): 14.

Davis, Douglas. "The New Color Painters." *Newsweek*, May 4, 1970, pp. 84-85.

Plagens, P. "Exhibition at Nicholas Wilder Gallery." *Artforum* 8 (May 1970): 82.

Colt, Priscilla. *Color and Field 1890-1970*.

The Albright-Knox Gallery, Buffalo, New York. Catalog, 1970. Plates 4 and 67.

Channin, Richard. "New Directions in Painterly Abstraction." *Art International* 14 (September 1970): 63.

Mikotajuk, A. "Goldowsky Gallery, New York, exhibit." *Arts* 45 (March 1971): 63.

Pincus-Witten, Robert. "New York." *Artforum* 9 (April 1971): 75.

Henning, Edward B. "Color and Field." *Art International* 15 (May 1971): 46-50.

Ratcliff, Carter. "New York Letter: Spring, Part III." *Art International* 15 (Summer 1971): 97-99.

Siegel, J. "Around Barnett Newman." *Art News* 70 (October 1971): 42.

Elderfield, J. "Abstract Painting in the 70s (an exhibition at the Boston Museum of Fine Arts)." *Art International* 16 (Summer 1972): 93.

Kramer, Hilton. *The New York Times*, October 28, 1972, p. 23.

Wilkin, Karen. "Dan Christensen: Recent Paintings." *Art International* 18 (Summer 1974): 57-58.

Baker, K. "Emmerich Uptown Gallery: New York Exhibit." *Art in America* 62 (September 1974): 107.

Bell, Jane. "Dan Christensen." *Arts* 49 (May 1975): 7.

Marshall, W. Neil. "Dan Christensen." *Arts* 49 (June 1975): 21.

## ALAN COTE

"On Exhibition." *Studio International* 179 (January 1970): 39.

Staber, M. "Brief aus Koln und Dusseldorf: drei Maler." *Art International* 14 (March 1970): 60.

Collin, Jane. "Reviews and Previews: Cote at Reese Paley." *Art News* 69 (December 1970): 14-16.

Sharp, Willoughby. "Paints of View, a Taped Conversation with Four Painters." *Arts* 45 (December 1970/January 1971): 41-42.

Domingo, Willis. "Galleries: Exhibition at Reese Palley." *Arts* 45 (February 1971): 55-57.

Henry, Gerrit. "New York Letter: Cote at Reese Palley." *Art International* 15 (February 1971): 81.

Pincus-Witten, Robert. "New York: Alan Cote at Reese Palley." *Artforum* 9 (March 1971): 62.

Tucker, Marcia. *The Structure of Color.* The Whitney Museum of American Art, New York, 1971.

Karin, Thomas. Junst Proxis Heute-Dumont, Cologne, West Germany. "Statement on Painting" by Alan Cote, 1972, p. 26.

Gilbert-Rolfe, Jeremy. "Review." *Artforum* 12 (January 1974): 74.

Kingsley, April. "A Return to Abstract Impressionism?" *Soho Weekly News,* December 4, 1975.

Rickey, Carrie. "Fashion/Style/Custom: Alan Cote and David Diao." *Artforum* 17 (October 1978): 30-34.

## TOM HOLLAND

Martin, Fred. "Tom Holland, the Byron Burford Paintings, Richmond Art Center." *Artforum* 1 (August 1962): 35.

Leider, Philip. "San Francisco: The Construction as an Object of Illusion." *Artforum* 1 (October 1962): 40.

Breckenridge, Betty. "San Francisco: 12th Annual Oil and Sculpture, Richmond Art Center." *Artforum* 1 (February 1963): 45.

Magloff, Joanna C. "San Francisco: Tom Holland, Exhibition at Lanyon Gallery." *Artforum* 1 (May 1963): p. 12.

Polley, Elizabeth M. "San Francisco: Tom Holland, Exhibition at Lanyon Gallery." *Artforum* 2 (May 1964): 46.

——————. "2D-3D at Richmond Art Center." *Artforum* 4 (June 1966): 49-50.

Gold, Barbara. "Corcoran Biennial: New Sensibility in Washington." *Arts* 43 (April 1969): 30.

Plagens, Peter. "Los Angeles: Exhibition at Nicholas Wilder Gallery." *Artforum* 8 (December 1969): 75.

Pincus-Witten, Robert. "New York: Exhibition at Robert Elkon Gallery." *Artforum* 8 (December 1970): 83.

Ratcliff, Carter. "New York: Exhibition at Robert Elkon Gallery." *Art International* 14 (Summer 1970): 144.

Richardson, Brenda. "Bay Area Survey: Exhibition at Hansen Fuller Gallery." *Arts* 45 (November 1970): 54.

Tarshis, Jerome. "San Francisco: Exhibition at Hansen Fuller Gallery." *Artforum* 9 (December 1970): 84.

Gollin, Jane. "Reviews and previews — Tom Holland: Exhibition at Lawrence Rubin Gallery." *Art News* 71 (December 1972): 12.

Siegel, Jeanne. "Reviews and previews — Tom Holland: Exhibition at Lawrence Rubin Gallery." *Art News* 71 (December 1972): 12.

Whittet, G. "London: Exhibition at Felicity Samuel Gallery." *Art and Artists* 8 (June 1973): 42.

Andre, Michael. "Reviews and previews — Tom Holland: Exhibition at Knoedler Gallery." *Art News* 72 (December 1973): 90.

King, Mary. "St. Louis — Tom Holland: Exhibition at Greenberg Gallery." *Arts* 49 (November 1974): 27.

Smith, Griffin. "Reviews and previews — Miami: Exhibition at Corcoran Gallery." *Art News* 74 (January 1975): 82.

Albright, Thomas. "San Francisco Kinetic Painting: Exhibition at Hansen Fuller Gallery." *Art News* 75 (February 1976): 77-78.

Cavaliere, Barbara. "Exhibition at Droll Kolbert Gallery." *Arts* 53 (December 1978): 24.

Bell, Jane. "New York Reviews: Tom Holland: Exhibition at Droll Kolbert Gallery." *Art News* 78 (January 1979): 157.

Albright, Thomas. "The Nation: San Francisco: Star Streaks: Exhibition at San Francisco Art Institute." *Art News* 78 (April 1979): 101.

## YVONNE JACQUETTE

Glueck, G. "Fischbach Gallery, New York, exhibit." *Art in America* 59 (May 1971): 132.

Henry, G. "Real Thing." *Art International* 16 (Summer 1972): 90.

Alloway, Lawrence. "Review." *The Nation,* November 6, 1972.

Kingsley, April. "Direct Representation." *Artforum* 10 (November 1972): 28.

Kramer, Hilton. "Extreme Cross-Purposes." *The New York Times,* December 10, 1972.

Schjeldahl, Peter. "Realism — A Retreat to the Fundamentals." *The New York Times,* December 24, 1972.

Nochlin, Linda. "Some Women Realists." *Arts* 48 (February 1974): 46-51.

Perlmutter, E. F. "Brooke Alexander Gallery, New York, exhibit." *Art News* 74 (January 1975): 107.

Lippard, Lucy. "A New Landscape Art." *From the Center, Feminist Essays on Women's Art* (New York: Dutton, 1976). Reprinted, *Ms.,* April 1977.

Russell, John. "Women Artists with Growing Authority." *The New York Times,* November 14, 1976.

Goldman, Judith. "Touching Moonlight." *Art News* 77 (November 1978).

Ratcliff, Carter. "Contemporary American Painting." *Decade, the Magazine of Contemporary Art and Culture,* January 1979.

Kramer, Hilton. "Art: Yvonne Jacquette." *The New York Times,* April 27, 1979.

Yeh, Susan Fillin. "Yvonne Jacquette." *Arts* 53 (May 1979): 10.

Schjeldahl, Peter. "Exhibition at Fischbach Gallery." *Art International* 13 (November 1969): 70.

Elliot, David. "Realism is in a..." *Chicago Sun Times,* December 2, 1979.

Artner, Alan G. "Realism with a Personal Touch." *Chicago Tribune,* January 4, 1980.

## KEN KIFF

Foss, Michael, ed. *Folk Tales of the British Isles*. Illustrated by Ken Kiff. (London: Macmillan London, Ltd., 1977)

Hyman, Timothy. *Narrative Paintings, Figurative Art of Two Generations*. Arnolfini Gallery, London, 1979, sponsored by the Arts Council of Great Britain.

_____. "Ken Kiff." *Artscribe Magazine* 17 (May 1979).

Nicola Jacobs Gallery, London. "Ken Kiff, Paintings and Drawings." February 12 — March 8, 1980. Catalog.

Feaver, William. "Review." *Vogue*, January 1980.

*London Observer*, February 17, 1980.

Mason, Michael. "In Pursuit of Visual Rhymes." *Times Literary Supplement*, February 22, 1980.

Crichton, Fenella. *Art and Artists* 14 (April 1980): 45.

Denvir, B. "Exhibition in London." *Art International* 14 (April 1970): 60.

Morgan, S. "Nicola Jacobs Gallery, London, exhibit." *Artforum* 18 (April 1980): 86.

## JOAN SNYDER

Baker, K. "Bykert Gallery, New York, exhibit." *Artforum* 9 (April 1971): 81.

Robbin, Tony. "A Protean Sensibility." *Arts* 45 (May 1971): 28-30.

Tucker, Marcia. "The Anatomy of a Stroke: The Recent Paintings of Joan Snyder." *Artforum* 9 (May 1971): 42-45.

Stiles, K. "Michael Walls Gallery, San Francisco, exhibit." *Artforum* 10 (November 1971): 87.

"Portraits of Young Artists." *Newsweek*, February 7, 1972, p. 79.

Bowling, F. "Revisions: Color and Recent Painting." *Arts* 46 (March 1972): 47-50.

Hughes, Robert. "Myths of Sensibility." *Time*, March 20, 1972, pp. 72-73.

Baker, Kenneth. *Christian Science Monitor*, April 20, 1972, p. 8.

Elderfield, John. "Grids." *Artforum* 10 (May 1972): 53.

_____. "The Whitney Annual." *Art in America* 60 (May-June 1972): 27, 29.

Kingsley, April. "Women Choose Women." *Artforum* 11 (March 1973): 73.

Davis, Douglas. "Art Without Limits." *Newsweek*, December 24, 1973, pp. 68-74.

_____. "American Art on the Loose Again." *Horizon USA*, February 1974, pp. 53-58.

Baker, K. "Institute of Contemporary Art, Boston, exhibit." *Art in America* 63 (March 1975): 105.

Iskin, Ruth. "Toward a Feminist Perspective: The Art of Joan Snyder." *Chrysalis* 1 (1976): 101-15.

Herrera, Hayden. "Carl Solway Gallery, New York, exhibit." *Art in America* (May 1976): 103-04.

Ratcliff, C. "Paint Thickens." *Artforum* 14 (June 1976): 47.

Webster, Sally. "Joan Snyder, Fury and Fugue: Politics of the Inside." *The Feminist Art Journal* 5 (Summer 1976).

Bell, Jane. "Drawing, Now, Then and Again." *New York Arts Journal* 7 (November-December 1977): 13-14.

Welish, M. "Hamilton Gallery, New York, exhibit." *Art in America* 66 (July 1978): 114.

McDonald, R. "Images Public and Private: San Francisco Art Institute exhibit." *Artweek* 10 (December 8, 1979): 4.

## WILLIAM TUCKER

Baro, G. "Britain's Young Sculptors." *Arts* 40 (December 1965): 14.

Dienst, R. G. "Drei aspekte der neuen englishchen plastik." *Kunstwerk* 19 (March 1966): 11-15.

Jouffroy, A. "Art de demi brume à Londres." *Oeil* 149 (May 1967): 37-38.

Lucie-Smith, E. "William Tucker and Pol Bury at Kasmin." *Studio* 173 (May 1967): 254.

Ammann, J. C. "Anthony Caro und die junge englische skulptur." *Werk* 54 (October 1967): 644.

Kudielka, R. "London im herbst." *Kunstwerk* 21 (October 1967): 46.

Melville, R. "Young Consolidators: the Interim: show at Whitechapel." *Architectural Review* 144 (July 1968): 64.

Pinney, M. "Exhibition at Kasmin Gallery." *Arts Canada* 26 (August 1969): 44.

Russell, J. "New Names in London: A to Z." *Art in America* 58 (September 1970): 99.

Packer, W. "Kasmin Gallery, London, exhibit." *Art and Artists* 5 (October 1970): 34.

Burr, J. "London Galleries: Kasmin Art Gallery, exhibit." *Apollo* 92 (November 1970): 385.

Laurens, Henri. "Exhibition at the Hayward." *Studio* 182 (July 1971): 24-25.

Alloway, Lawrence. "Caro's Art — Tucker's Choice." *Artforum* 14 (October 1975): 65-71.

Chapman, Hilary. "Condition of Sculpture." *Arts* 50 (November 1975): 68-69.

Elsen, Albert. "Review of William Tucker's Early Modern Sculpture." *Art Journal* 35 (Winter 1976): 136-38.

Kramer, Hilton. *The New York Times*, April 8, 1977.

Baker, Kenneth. "William Tucker; Meaning vs. Matter." *Art in America* 65 (November/December 1977): 102-03.

Spalding. "William Tucker Sculptures (exhibit)." *Connoisseur* 196 (November 1977): 233.

"Modernism, Freedom, Sculpture." *Art Journal* 37 (Winter 1977-78): 153-56.

Kramer, Hilton. "Triumphant New Work by Two Artists." *The New York Times*, Sunday, May 25, 1979.

Ashton, Dore. "William Tucker's Gyre." *Arts* 53 (June 1979): 128-29.

Berlind, R. "Elkon Gallery, New York, exhibit." *Art in America* 67 (October 1979): 122.

## Acknowledgments

**56**

This catalog is published on the occasion of the exhibition "New Work on Paper 1" at The Museum of Modern Art. As author of the catalog and director of the exhibition, I am obliged to many individuals for their generosity and assistance in bringing this project to fruition. Chief among these are the eight artists in the exhibition and their respective dealers: Jake Berthot and the David McKee Gallery, New York; Dan Christensen and the Salander-O'Reilly Galleries, New York, Meredith Long and Company, Houston, and the Douglas Drake Gallery, Kansas City, Kansas; Alan Cote and the Betty Cuningham Gallery, New York; Tom Holland and the Blum/Helman Gallery, New York and the Hansen Fuller Goldeen Gallery, San Francisco; Yvonne Jacquette and Brooke Alexander, Inc., New York; Ken Kiff and the Nicola Jacobs Gallery, London; Joan Snyder and the Hamilton Gallery of Contemporary Art, New York; and William Tucker and the Robert Elkon Gallery, New York. Special thanks are also due to the other lenders to the exhibition: Ms. Lois E. Dickson, Mr. Malcolm Goldstein, Mr. and Mrs. S. I. Newhouse, Jr., Dr. Felicia Sachs, Ms. Donna Sands, Dr. Thomas S. Schultz, Mr. John Walker, Mr. Edward Wolf, and three lenders who preferred to remain anonymous.

At The Museum of Modern Art, I am particularly indebted to Beatrice Kernan, Curatorial Assistant in the Department of Drawings, and to my assistant, Diane Gurien, for their coordination of matters relating to the exhibition and the publication respectively. Others to whom special thanks are due include: Elizabeth Carpenter of the Registrar's Department; Jerry Neuner of the Department of Operations; Antoinette King, Senior Paper Conservator; Susan Weiley, who edited this publication; and Keith Davis, who designed it. Finally, The Museum of Modern Art is grateful for generous support from the National Endowment for the Arts, which made this exhibition and publication possible.                                        J.E.